CHINESE BRUSH PAINTING FOUR SEASONS

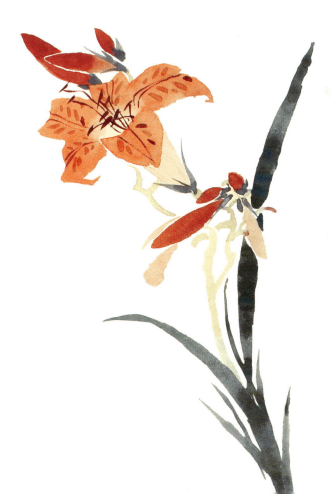

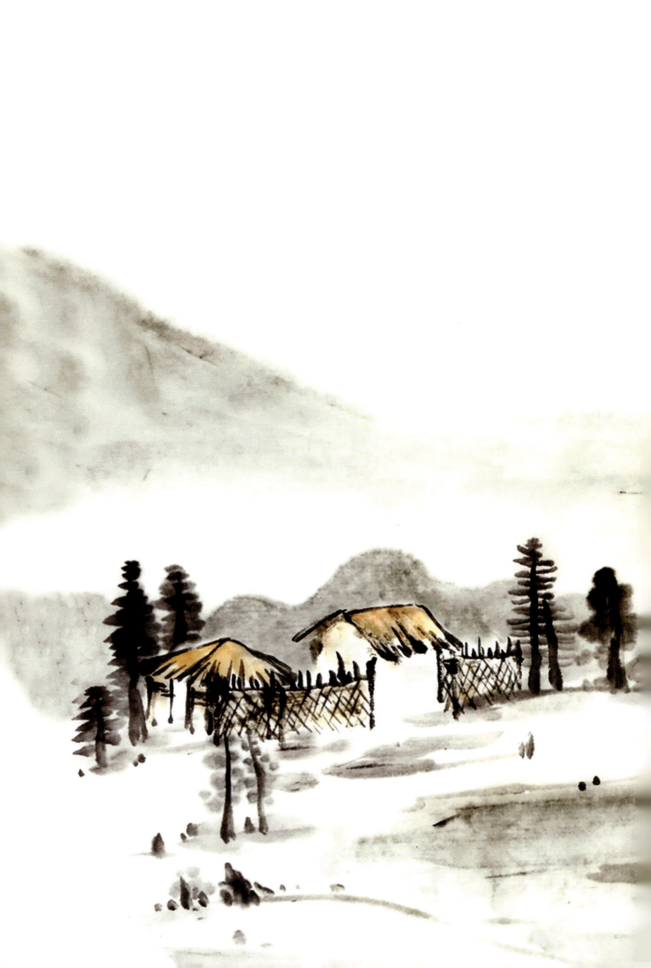

CHINESE BRUSH PAINTING FOUR SEASONS

Paint Flowers, Birds & More
with
24 Step-by-Step Projects

By Fei Le Niao

SCPG

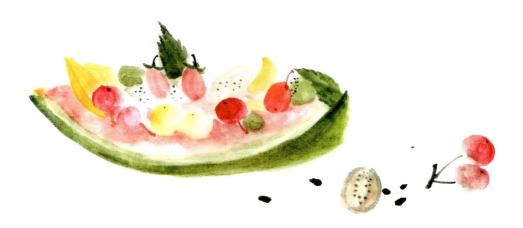

Copyright © 2023 Shanghai Press and Publishing Development Co., Ltd.
All rights reserved. Unauthorized reproduction, in any manner, is prohibited.

Text and Photographs: Fei Le Niao
Translation: Shelly Bryant
Cover Design: Wang Wei
Interior Design: Hu Bin, Li Jing (Yuan Yinchang Design Studio)

Assistant Editor: Qiu Yan
Editor: Cao Yue

ISBN: 978-1-93836-898-1

Address any comments about *Chinese Brush Painting: Four Seasons* to:

SCPG
401 Broadway, Ste. 1000
New York, NY 10013
USA

or

Shanghai Press and Publishing Development Co., Ltd.
Floor 5, 390 Fuzhou Road, Shanghai, China (200001)
Email: sppd@sppdbook.com

Printed in China by Shanghai Donnelley Printing Co., Ltd.

1 3 5 7 9 10 8 6 4 2

On page 1
Fig. 1 *Crabapple Flower, Lily, and Butterfly*
The crabapple flower (upper left), known in China as "the fairy in the flower," symbolizes love and beauty. The lily (lower right) symbolizes a harmonious family and a happy marriage. The two butterflies fluttering among the flowers turn the static image into one full of vitality.

On pages 2–3
Fig. 2 *Minor Cold*
This small landscape painting depicts the Minor Cold solar term. Outside the two thatched huts situated at the foot of the snow-capped mountains are several pine and cypress trees, which are capable of withstanding even the severe cold. The painting projects a strong winter atmosphere with simple black colors.

Above
Fig. 3 *Colorful Fruits*
The juxtaposition of fruits of various colors creates a rich image.

CONTENTS

Preface *9*

Chapter One Tools and Materials *11*
1. Brush *11*
2. Ink *14*
3. Paper *15*
4. Inkstone *16*
5. Pigment *17*

Chapter Two Spring Painting *19*
1. Beginning of Spring *20*
2. Rain Water *24*
3. Awakening of Insects *29*
4. Spring Equinox *34*
5. Pure Brightness *38*
6. Grain Rain *43*

Chapter Three Summer Painting *49*
1. Beginning of Summer *50*
2. Grain Buds *55*
3. Grain in Ear *59*
4. Summer Solstice *63*
5. Minor Heat *67*
6. Major Heat *72*

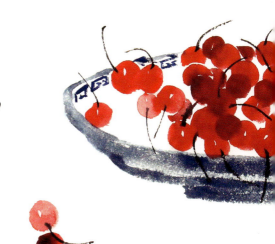

Fig. 4 *Red Cherries*
The ripe red cherries on a blue and white porcelain plate form a simple, vivid image.

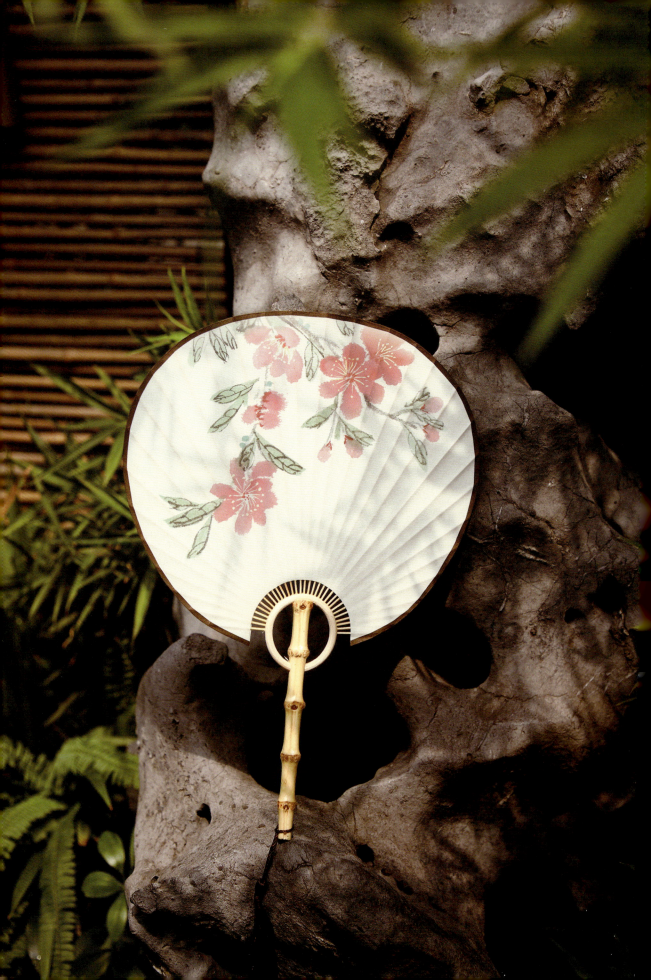

CONTENTS

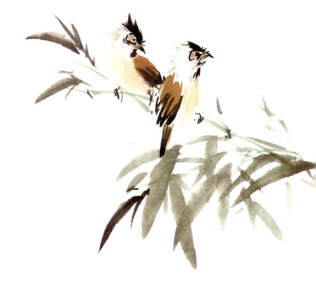

Chapter Four Autumn Painting *77*

 1. Beginning of Autumn *78*

 2. End of Heat *83*

 3. White Dew *86*

 4. Autumn Equinox *91*

 5. Cold Dew *95*

 6. Frost's Descent *99*

Chapter Five Winter Painting *105*

 1. Beginning of Winter *106*

 2. Minor Snow *111*

 3. Major Snow *115*

 4. Winter Solstice *119*

 5. Minor Cold *123*

 6. Major Cold *128*

Above
Fig. 6 *Bird and Bamboo*
Two birds fly onto a clump of bamboo and assume different postures, one raising its head to sing and the other turning its head to look around. The impact of the postures is very dynamic.

Bottom
Fig. 7 *Fish and Fallen Flower*
Fish have many auspicious associations in China, including wealth, prosperity, and love. In this painting, a pair of fish are drawn to a flower that has fallen into the water, creating a small ripple. The painting depicts water through the use of blank space, creating an ethereal effect that provokes the imagination.

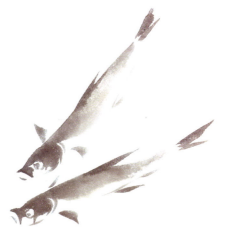

On facing page
Fig. 5 *Round Fan*
In this ink painting on a round fan, lovely, gentle pink blossoms are set against green leaves.

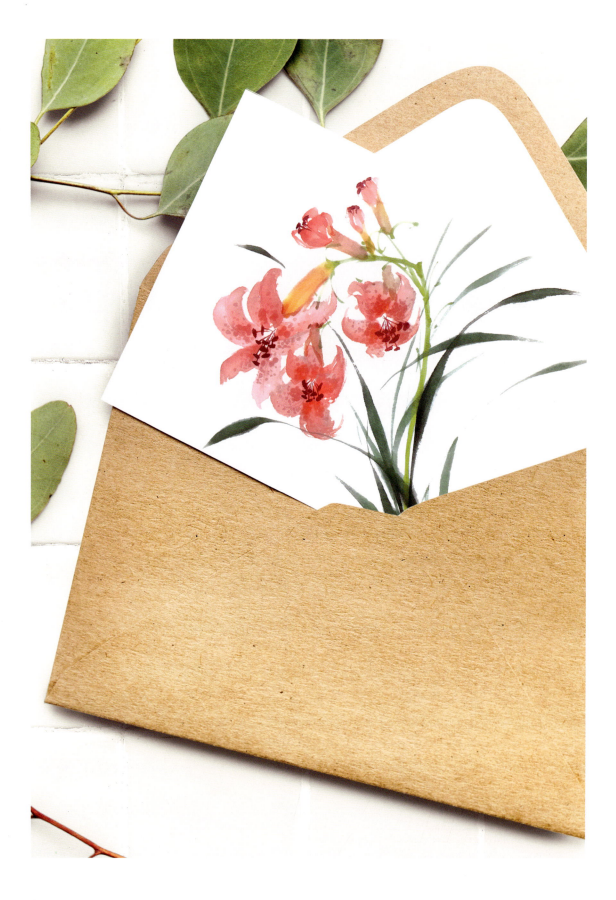

Preface

For thousands of years, the Chinese have divided a year into 24 solar terms, with six solar terms for each season. Mirroring the changes in climate and phenology, solar terms play a key role in daily life. For example, they guide farming activities and impact people's diet, clothing, housing, and transportation. Many customs and habits related to solar terms have been preserved to this day, and a large number of literary and artistic works with solar terms as the theme have been generated, constituting an essential part of traditional Chinese culture. The 24 solar terms constitute a knowledge system of laws summarized by the ancients in their age-old contacts with nature, which perfectly integrates astronomy, farming, phenology, folk customs, and philosophical ideas, suggesting good wishes and wisdom for people to live in harmony with nature. In 2016, the solar terms were placed on UNESCO's intangible cultural heritage list.

In the form of traditional Chinese painting, this book presents the various climatic characteristics of the 24 solar terms and their representative flowers, birds, fish, insects, fruits, vegetables, figures, and landscapes in separate and individual terms, along with an introduction to the solar terms.

The book presents the paintings associated with the 24 solar terms in the order of spring, summer, autumn, and winter. With each painting there is an introduction to a new painting technique. Plenty of blank space is left to encourage readers who love Chinese painting but dare not try it to create poetic pictures.

As well as painting on traditional paper, you can paint directly onto bookmarks, postcards, envelopes, or paper bags to give them to your friends as gifts. You can also put your artistic creations on everything from cups and penholders to notebooks, enhancing ordinary stationery.

Now, let's start our journey through the traditional beauty of the 24 solar terms.

On facing page

Fig. 8 *Postcard*

The lily in the painting symbolizes good wishes. Painted on a postcard, it is a special gift to be given to friends.

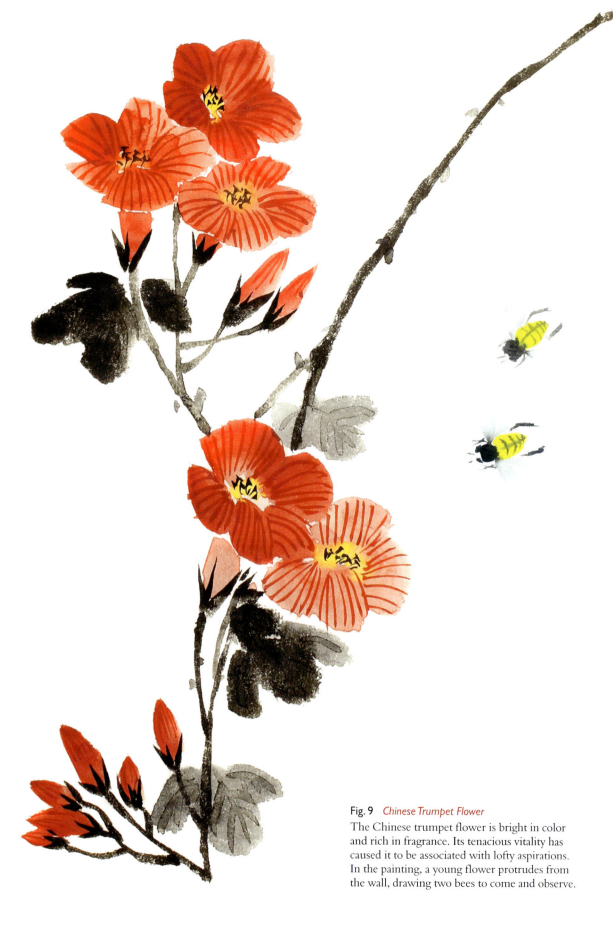

Fig. 9 *Chinese Trumpet Flower*
The Chinese trumpet flower is bright in color and rich in fragrance. Its tenacious vitality has caused it to be associated with lofty aspirations. In the painting, a young flower protrudes from the wall, drawing two bees to come and observe.

10 Chinese Brush Painting: Four Seasons

CHAPTER ONE
Tools and Materials

The tools of traditional Chinese painting are collectively referred to as the "four treasures"—brush, ink, paper, and inkstone. The paintbrush is a traditional writing and painting tool originating in China, and is made of animal hair or bird feathers. Although ink has a single color, it is indispensable in traditional writing and painting. With this ingenious material, the exquisite artistic conception of Chinese calligraphy and painting can be fulfilled. Paper is one of the four great inventions of ancient China, and the types of Chinese painting paper are quite specific. The inkstone—one of the four treasures of the study—has been gradually replaced by ink and ink plates as a result of social progress, and is now more for collectors. Besides, painting cannot be done without pigments. In *The Record of the Classification of Old Painters*, a work of Chinese painting theory from the Southern dynasties (420–589), the method of coloring according to categories was proposed, whereby the objects in the painting were divided into categories, with one color applied to each. This chapter briefly explains the basics of the "four treasures" and the fundamental blending of pigments.

1. Brush

There are a variety of ink brushes, including weasel-hair, goat-hair, and

Weasel-hair brush.

Goat-hair brush.

Mixed-hair brush.

Sharp.

Round.

Strong.

Neat.

mixed-hair. Weasel-hair brushes are elastic, and are generally used to outline tree branches or trunks. Goat-hair brushes are highly absorbent, and are used for coloring and broad strokes. Mixed-hair brushes are moderately elastic and absorbent, and are good for outlining and coloring.

 The basic standards for a good ink brush are that it should be "sharp, round, strong, and neat." "Sharp" means that the tip of the brush must be pointed; "round" means that the belly of the brush becomes round and full when absorbing water; "strong" means that the brush must have some

Mixed-hair brush for painting.

Weasel-hair brush for outlining.

Goat-hair brush for painting.

Detail painting brush for outlining.

elasticity; and "neat" means that the hair of the brush is of the same length when splayed.

In this book, a mixed-hair brush is used for coloring a small area, a weasel-hair brush for outlining branches and stems, and a goat-hair brush for rendering pictures and coloring a large area. The fine strokes mentioned, such as for leaf veins and stamens, are achieved with a detail painting brush of any model. In painting, the direction of the brush generally changes according to the shape of the object.

2. Ink

In addition to ink and ink sticks that are classified based on form, pine-soot ink and oil-soot ink are categorized according to material. Pine-soot ink is made from pine ash, the color of which is relatively solid and ideal for *xieyi* (freehand brushwork) in painting. Oil-soot ink is made from the burning of a specific vegetable oil or animal oil. It is brilliantly dark, and adds a layer of gloss to *gongbi* (fine brushwork).

Pine-soot ink.

In addition to the choice of ink, the grasp of the layers of ink color is a fundamental skill. Ink color is divided into five layers:

Coke ink: ink poured directly from the bottle.

Dark ink: coke ink plus 10% clear water, at a ratio of 1:9 clear water to coke ink.

Heavy ink: coke ink plus 20% clear water, with a color lighter than that of dark ink, at a ratio of 2:8 clear water to coke ink.

Light ink: a ratio of clear water to coke ink at 6:4.

Clear ink: the lightest, with the ratio of clear water to coke ink at 8:2 or 9:1.

For both ink and color, the most basic method is to use one stroke to present the changes in strokes and ink color, such as when painting leaves or distant mountains. Please see the steps on the right page.

Oil-soot ink.

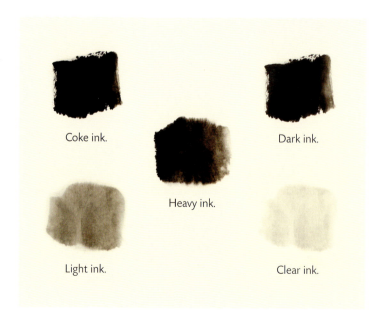

Coke ink.

Dark ink.

Heavy ink.

Light ink.

Clear ink.

14 Chinese Brush Painting: Four Seasons

 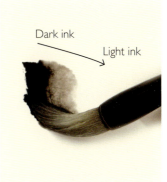

Dip the belly of the brush in the light ink.

Dip the tip in the dark ink.

Use a side-brush stroke to display the changes in the ink color (see p. 21 for side-brush stroke techniques).

3. Paper

Different types of paintings require different paper, generally ripe *xuan* paper, raw *xuan* paper, and mixed (half raw half ripe) *xuan* paper. The works in this book use the latter two for painting.

Ripe *xuan* paper: not absorbent, basically ink proof, mostly for fine brushwork.

Raw *xuan* paper: highly absorbent, not ink proof, mostly for freehand brushwork.

Mixed *xuan* paper: not as absorbent as raw *xuan* paper and more absorbent than ripe *xuan* paper, mostly for freehand brushwork, and easier for handling strokes.

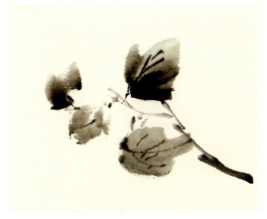

Raw *xuan* paper.

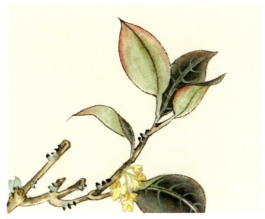

Ripe *xuan* paper.

Mixed *xuan* paper.

CHAPTER ONE Tools and Materials | 5

Duan inkstone.

She inkstone.

Tao inkstone.

Chengni inkstone.

4. Inkstone

An inkstone is used to grind the ink stick. There are four prestigious inkstones in China: *Duan* from Guangdong, *She* from Anhui, *Tao* from Gansu, and *Chengni* from Shanxi. Clear water is dripped on the surface of the inkstone, and then ground gently with an ink stick.

Natural pigments.

Chemical pigments.

5. Pigment

There are two types of pigments for Chinese painting: natural and chemical. Natural pigments are generally divided into plant and mineral pigments: the former is more transparent, such as gamboge, while the latter is opaquer, such as azurite. Chemical pigments are modern industrial products, and are widely used for their convenience. However, they are more likely to fade, and are harder to sustain than natural pigments.

For the blending of pigments, apart from the use of water to soften the intensity, the blending of color and ink and of various colors is often used in painting. Here are some examples.

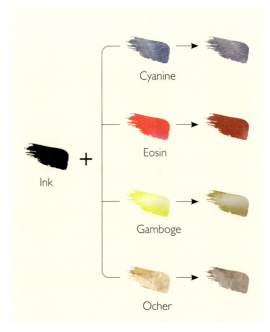

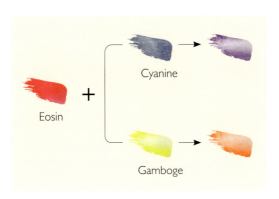

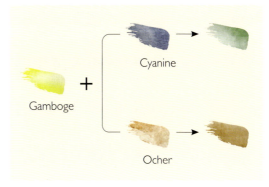

CHAPTER ONE Tools and Materials | 7

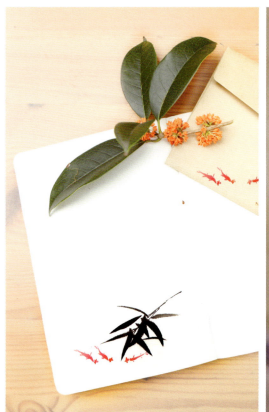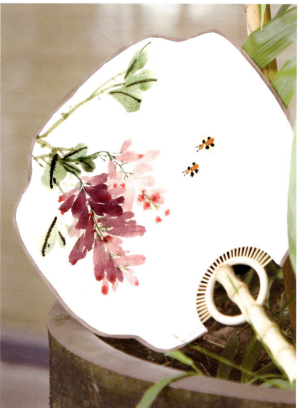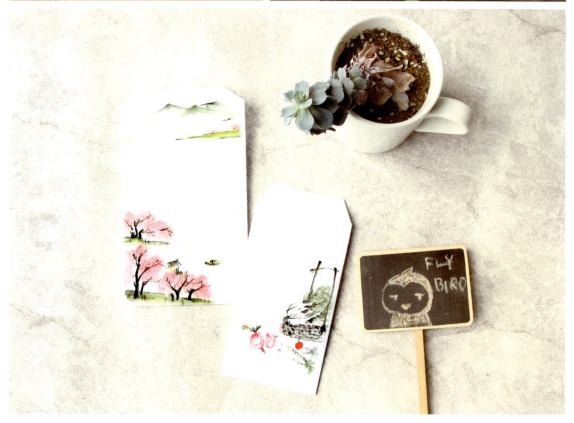

Chinese Brush Painting: Four Seasons

CHAPTER TWO
Spring Painting

As the old Chinese saying goes, the year's work starts in the spring. Spring is a fresh start, with warmer days and nature coming back to life. In the welcoming spring breeze, new grass breaks through the ground, buds hang over the branches, and flowers bloom, scenting the air with the fragrance of nature.

The works in this chapter depict the features of the solar terms from Beginning of Spring to Grain Rain. Before you start to paint, lay out your brush, ink, *xuan* paper, ink plate, and pigments, and then set your mind on the task of learning.

On facing page

Fig. 10 The application of ink painting on a notebook, a round fan, and envelopes.

Fig. 11 Willow and ducks in water.

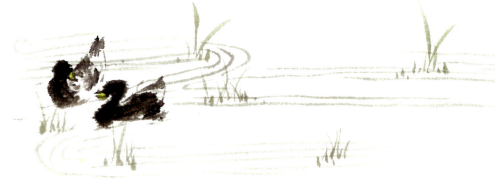

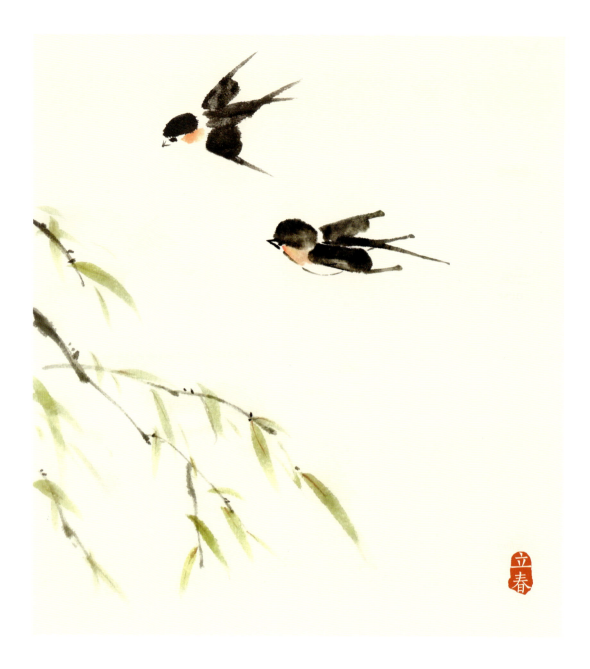

1. Beginning of Spring

Beginning of Spring is the first solar term of the year, falling between February 3 and 5. Despite the chill, everything is coming to life and nature is blooming. In ancient China, a welcoming ceremony was held on this day.

The spring scene depicted in this piece is based on a poem by Su Shi (1037–1101), a renowned poet in the Northern Song dynasty (960–1126). In the picture, the tender green willow branches are flowing in the wind, and two lovely swallows seem to be painted into the freshness of the lush scene. The picture renders the sense of a mild spring breeze.

Colors

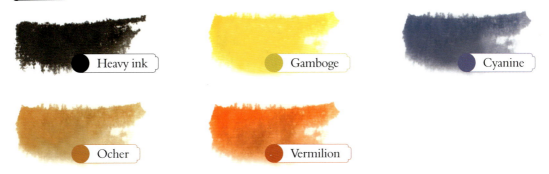

Painting Techniques

In Chinese painting, the way of moving the brush is referred to as a series of "strokes," which are mainly expressed in lines, the most common being *zhongfeng* (centered-tip stroke) and *cefeng* (side-brush stroke). With *zhongfeng*, the tip of the brush is held perpendicular to the paper to present thin lines, while with *cefeng*, the tip and the belly (midsection) are both used to paint thick lines.

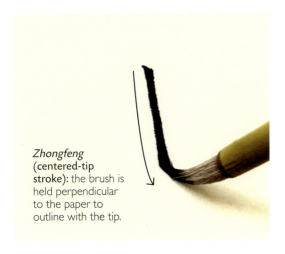

Zhongfeng (centered-tip stroke): the brush is held perpendicular to the paper to outline with the tip.

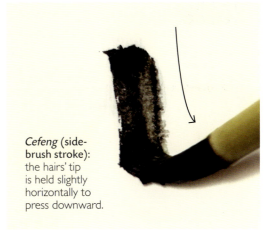

Cefeng (side-brush stroke): the hairs' tip is held slightly horizontally to press downward.

Steps

1

Paint a swallow at the bottom end using a combination of *zhongfeng* and *cefeng* to present the features in a freehand style. First, dip your brush into the heavy ink and press down the hairs' tip to paint the head.

2

Use *cefeng* to sketch one wing of the swallow.

CHAPTER TWO Spring Painting 21

3	4	5
Use *cefeng* to add the other wing.	Use *zhongfeng* to sketch the tail.	Use *zhongfeng* to sketch the lower part of the tail.
6	7	8
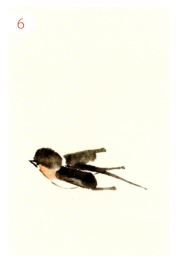	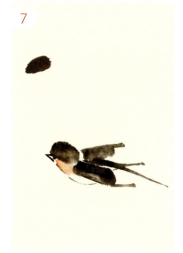	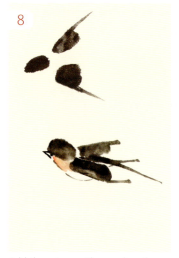
Use *zhongfeng* to sketch the mouth, eye, head, and belly; extend the wings on both sides; and brighten the neck with ocher and vermilion. The first swallow is complete.	Now work on the second swallow. Start with *zhongfeng*, then press down the hairs' tip to paint the head.	Add the wings with one *zhongfeng* stroke and one *cefeng*.

9

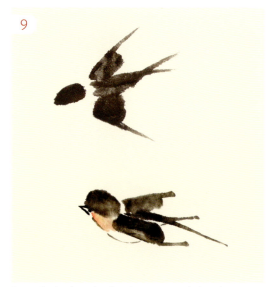

Paint the body and tail with two crossed *zhongfeng*.

10

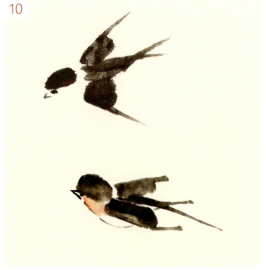

Refine the details of the head and paint the mouth and eye with *zhongfeng*. The second swallow is now complete.

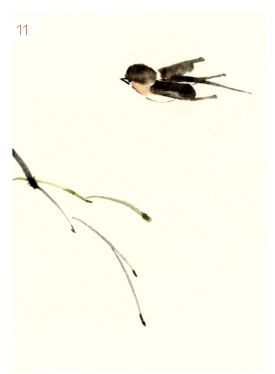

Now work on the willow branches. Start with *zhongfeng* to sketch the willow branches.

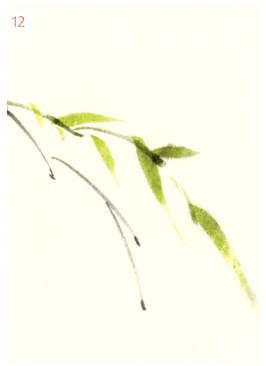

Blend cyanine and gamboge to the proportion of 4:6 to make light green, and move from *cefeng* to *zhongfeng* to sketch the budding leaves.

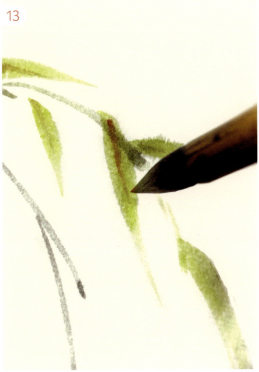

Refine the details of the leaves. In ocher, use *zhongfeng* to sketch selectively the veins of the leaves.

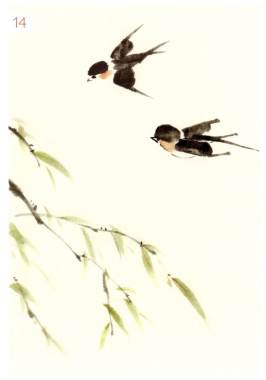

Paint other branches and leaves in the same way. The picture is now complete.

CHAPTER TWO Spring Painting 23

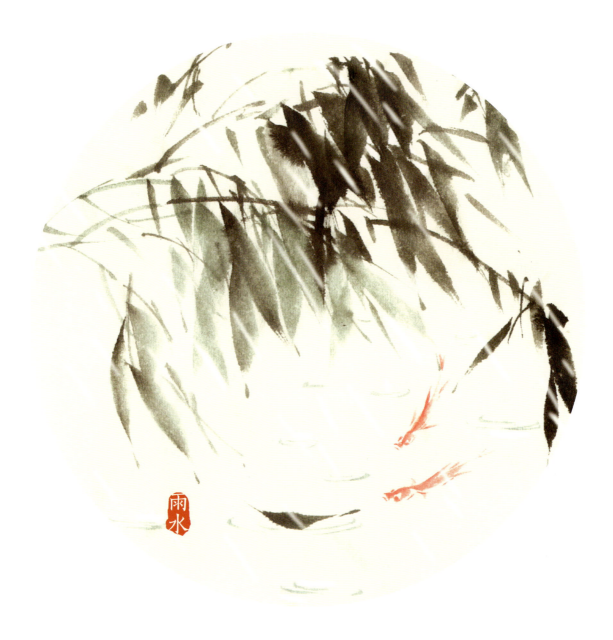

2. Rain Water

Rain Water is the second solar term of the year, falling between February 18 and 20, when the start of the rainfall enhances all of nature in the deepening of the spring.

 In the picture, the drizzle freshens a small pond and bamboo leaves. Two red fish swim at ease, breathing the fresh air on the surface of the water greedily. The bamboo leaves fall, stirring up layers of ripples in a dynamic scene.

Colors

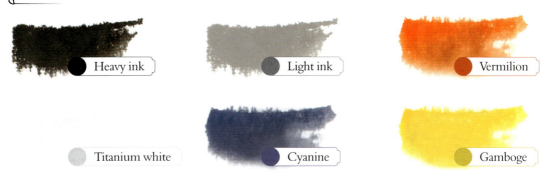

Painting Techniques

As well as *zhongfeng* and *cefeng*, other widely used Chinese brush strokes include *cangfeng* (hiding the hairs' tip) and *lufeng* (exposing the hairs' tip). In this section, we will learn these strokes by painting bamboo leaves. The former is applied in the beginning and closing strokes to turn the tip to make it full and round, while the latter is applied straightforwardly to reveal the tip.

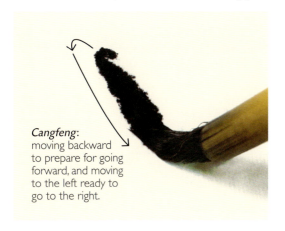

Cangfeng: moving backward to prepare for going forward, and moving to the left ready to go to the right.

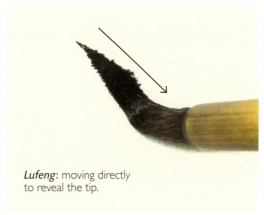

Lufeng: moving directly to reveal the tip.

Steps

1

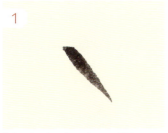

Paint the bamboo leaves. This should be done in groups to simplify the relatively complex mixture of the leaves. First, in heavy ink, start with *cangfeng* and close with *lufeng*.

2

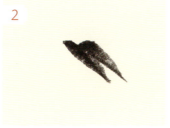

Make the second stroke in the same way.

3

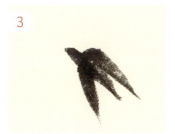

Paint the third bamboo leaf.

CHAPTER TWO Spring Painting 25

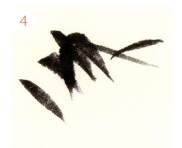
Continue to add leaves to this group.

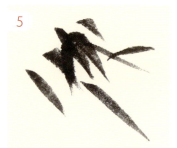
Paint the first stroke of a second group of bamboo leaves.

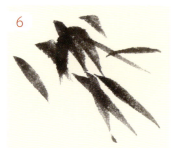
Continue to add leaves to the second group.

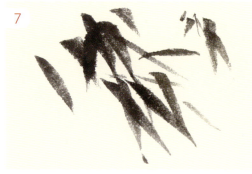
When the second group is done, paint the group of leaves at the top right.

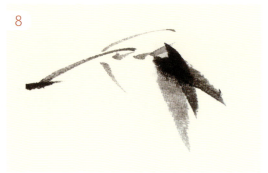
Add bamboo branches with light ink, and paint three blades of bamboo leaves in varying shades under the first group of leaves.

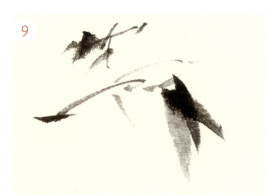
Refine the details of the bamboo branches and complete the first bamboo branch at the top.

Now paint the second bamboo branch in the lower part of the picture. Use heavy ink for the first stroke.

Add the leaves.

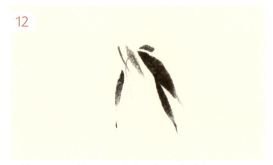
Add a group of leaves in light ink on the left.

26 Chinese Brush Painting: Four Seasons

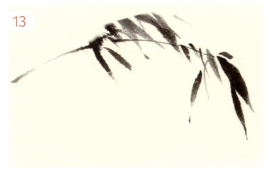

Sketch a bamboo branch and continue to add the leaves.

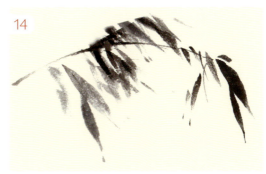

In light ink, add leaves under the branch.

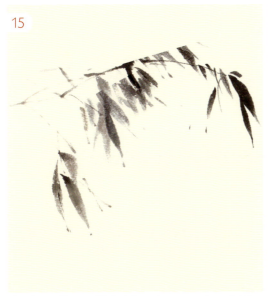

Blend vermilion and light ink to the proportion of 1:9 to refine the remaining leaves and add twigs. The bamboo leaves are now complete.

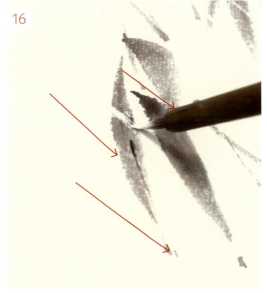

In thick titanium white, use *zhongfeng* with a detail painting brush to move swiftly in one direction to sketch fine lines for rain.

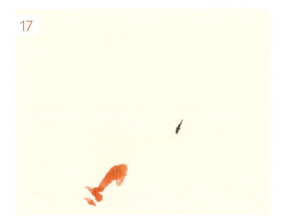

Now paint the fish, fallen leaf, and ripples. Sketch the head and back of the fish in vermilion; start with *zhongfeng* to sketch the head with two strokes, and then start with *zhongfeng* and close with *cefeng* to sketch the back.

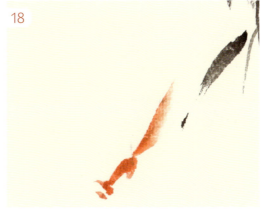

Start with *cangfeng* and close with *lufeng* to paint the fish tail.

CHAPTER TWO Spring Painting 27

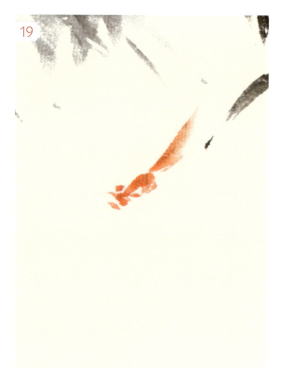

Refine the eyes of the fish.

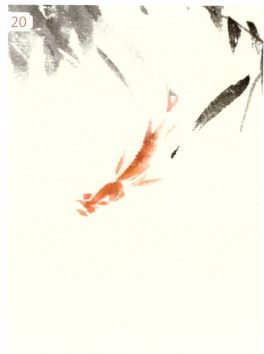

Refine the fins of the fish.

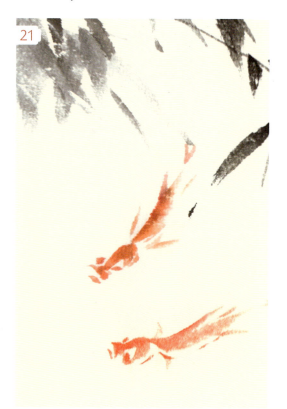

Paint the second fish in the same fashion.

Add the fallen leaf. Blend cyanine with a small amount of gamboge, and use a detail painting brush to sketch the ripples with *zhongfeng*. The picture is now complete.

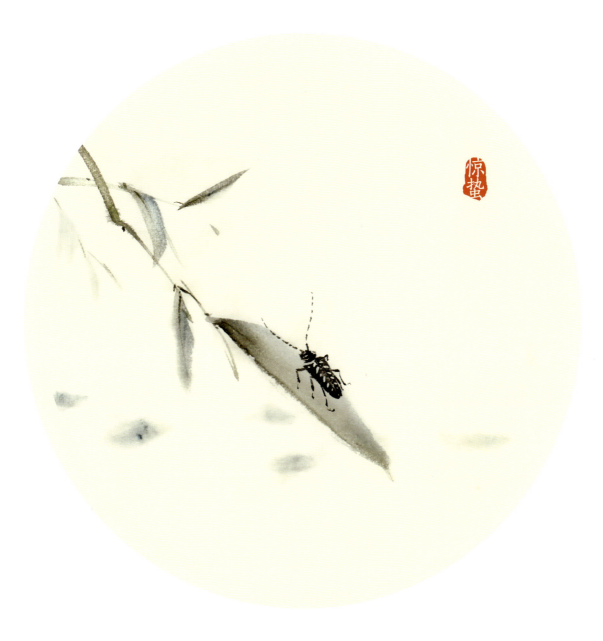

3. Awakening of Insects

Awakening of Insects is the third of the 24 solar terms, falling between March 5 and 6, when, with rising temperature, thunder awakens insects from hibernation to activity. To combat the dry weather, Chinese people have formed the habit of eating pears to moisten the lungs and prevent coughing.

The image here is simple and plain, depicting a longicorn beetle crawling quietly on a leaf blade. It appears to have just woken from hibernation, and is cautiously reaching out with its antennae into the scent of spring.

Colors

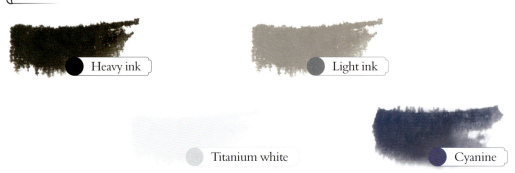

Painting Techniques

Chinese brush strokes are generally complementary to each other, and are used in an integrated way, such as *zhongfeng* shifting to *cefeng*, and vice versa. Here we use the painting of a leaf to demonstrate the shifting of *zhongfeng* to *cefeng*. As shown in the picture, start with *zhongfeng* to paint the thin leaf root. Slowly turn to *cefeng* to paint the wider part of the leaf, and close with *zhongfeng*.

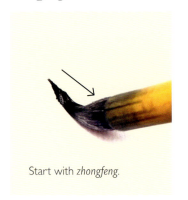

Start with *zhongfeng*.

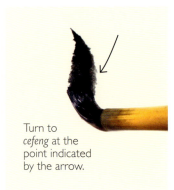

Turn to *cefeng* at the point indicated by the arrow.

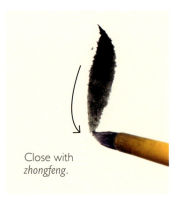

Close with *zhongfeng*.

Steps

1

Paint the leaves. Paint the main leaf by shifting from *zhongfeng* to *cefeng* and to *zhongfeng* again.

2

Add a small leaf to the left of the main leaf.

30 Chinese Brush Painting: Four Seasons

Add another small leaf above the leaf from last step.

Continue to add small leaf.

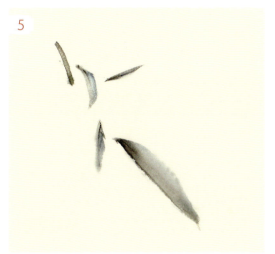

Paint part of a branch with *zhongfeng*.

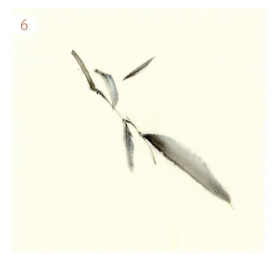

Paint the branch to link the first group of leaves.

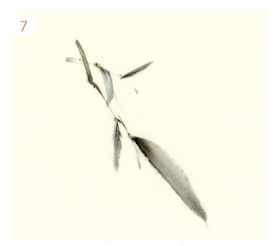

Add twigs to link the second group of leaves above the first.

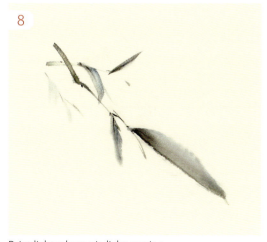

Paint lighter leaves in light cyanine.

CHAPTER TWO Spring Painting

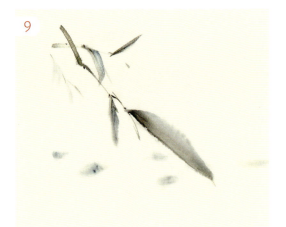

9

Dip the water-soaked brush in cyanine and dot under the leaves.

10

Now paint the longicorn beetle, with a small head. To see the steps clearly, the head is enlarged here. First, paint two short horizontal lines to sketch the head.

11

Add a slightly longer third stroke at the bottom.

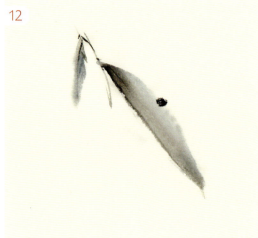

12

The head is now complete.

13

Add the left half of its back.

14

Complete the other half of the back and add the first foot on the left.

32 Chinese Brush Painting: Four Seasons

Add the second and third feet on the left.

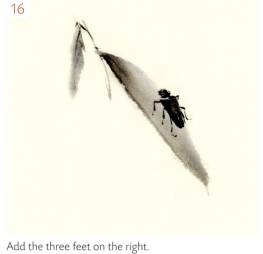

Add the three feet on the right.

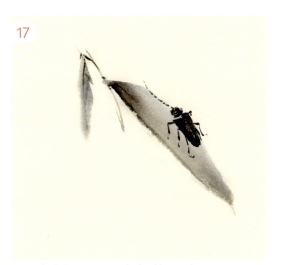

Paint the left antenna with dot-like strokes.

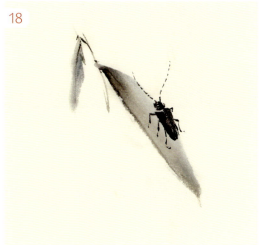

Add the right antenna.

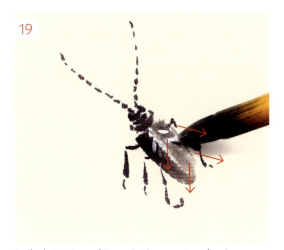

In thick titanium white, paint in an outward-going direction the white spots on both sides of the back.

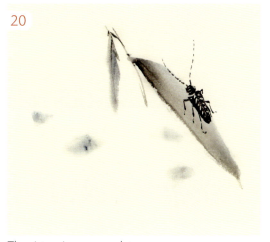

The picture is now complete.

CHAPTER TWO Spring Painting 33

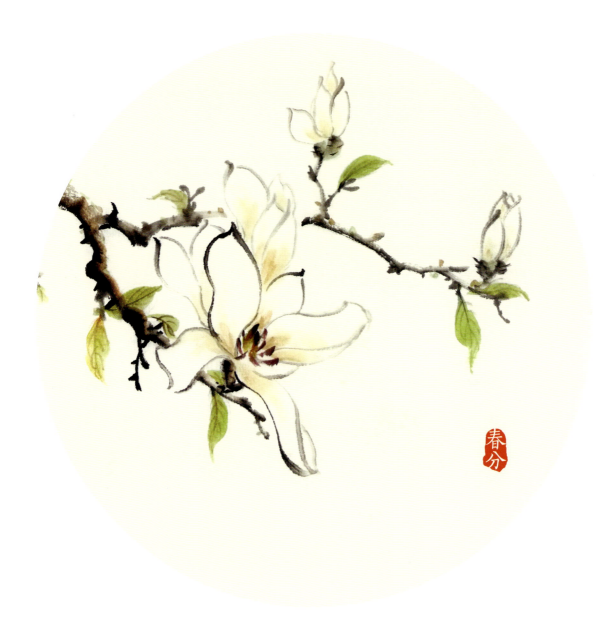

4. Spring Equinox

The Spring Equinox is the midpoint of spring, falling between March 19 and 22, when day and night are almost of the same length. On mild and fine days, Chinese people have the custom of flying kites and eating spring vegetables.

 The white magnolia in the picture blossoms in spring, and has a light fragrance. With a centuries-long history of cultivation in China, it is mostly found in classical gardens. A symbol of nobility and good wishes, it has served as a perfect subject for poetry, songs, and paintings since ancient times.

Colors

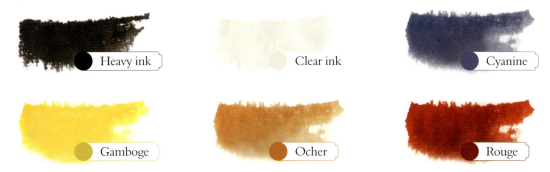

Heavy ink | Clear ink | Cyanine
Gamboge | Ocher | Rouge

Painting Techniques

In the *xieyi* (freehand) method, in addition to the traditional style that is used to sketch outlines with one or two strokes, there is also a "double-outline method" that uses lines to outline the shape. The former combines the shifting tip, while the latter primarily uses *zhongfeng* to sketch the outline of the object.

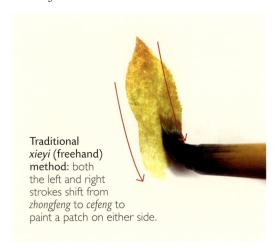

Traditional *xieyi* (freehand) method: both the left and right strokes shift from *zhongfeng* to *cefeng* to paint a patch on either side.

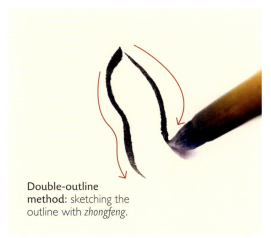

Double-outline method: sketching the outline with *zhongfeng*.

Steps

Use the double-outline method to paint the magnolia. First, use *zhongfeng* to make the first stroke.

Sketch the second stroke to complete the first petal.

Add a second petal.

CHAPTER TWO　Spring Painting　35

Add a third petal.

Add a fourth petal.

Add fifth and sixth petals.

Continue to use *zhongfeng* to refine the petals in the distance.

Add another bud in the same fashion.

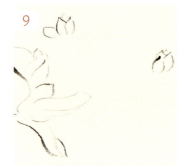
Add a second bud.

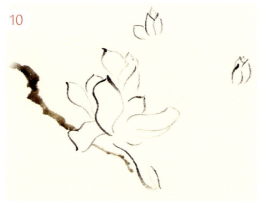
Color the flowers when the outline is sketched. To highlight the whiteness of the magnolia, refrain from using thick color. First, paint the first branch with a mixture of ocher and ink to the proportion of 7:3.

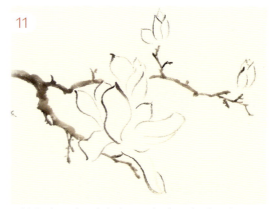
Add the branch to link the two buds and refine the details of the branch.

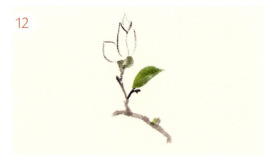
Blend cyanine and gamboge into green to the proportion of 4:6 to paint the leaf, and add a small amount of clear ink to paint the receptacle.

Blend cyanine and gamboge to the proportion of 4:6 into green, add clear water to the green to dilute, and paint other leaves.

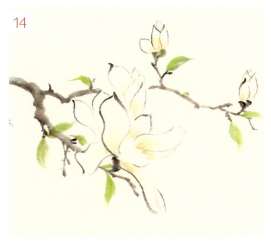

Blend ocher and gamboge to the proportion of 3:7 to color the root of the petals.

Dot the stamens in rouge.

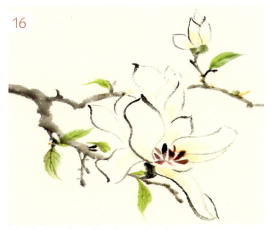

Sketch the veins of the leaves in ocher.

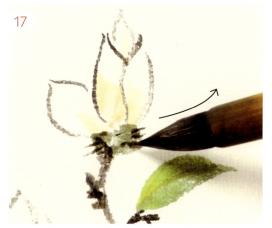

Refine the details of the receptacle; swiftly paint small dots in thick color with the brush tip and lift the tip quickly (this is termed *diantai* in Chinese painting).

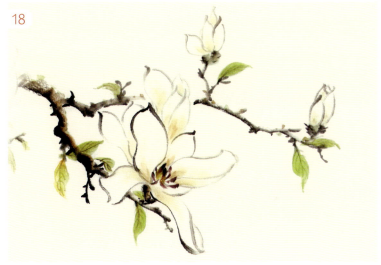

Refine the details in heavy ink, and deepen the dark part of the branches to complete the painting.

CHAPTER TWO Spring Painting 37

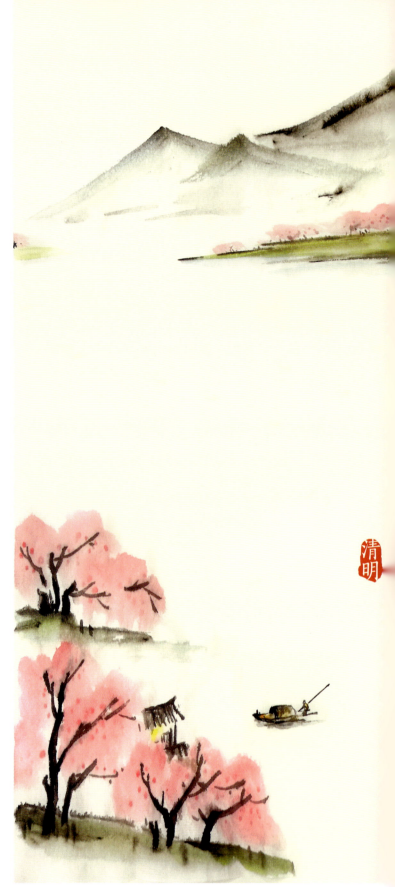

5. Pure Brightness

Pure Brightness is the fifth solar term in spring, falling between April 4 and 5, when flowers are in full bloom. It is also one of the most important sacrificial festivals in Chinese tradition. Chinese people preserve the custom of tomb sweeping, ancestor worshiping, and going on outings on fine spring days.

The picture is a spring landscape painting, using the *liubai* (leaving blank) technique to render a tranquil water surface between the foreground scene and the distant mountains. *Liubai* is one of the most widely-used techniques in Chinese traditional art, carrying the artistic conception that "less is more," and offering plenty of room for imagination. In the picture, against the backdrop of peach blossoms blooming over the mountain, a skiff is returning from an outing, rendering a sense of spring that is both serene and dynamic.

38　Chinese Brush Painting: Four Seasons

Colors

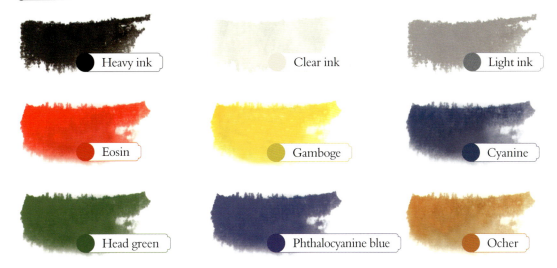

Painting Techniques

The *xieyi* (freehand) method contains several "breaking" techniques, one of which is explained here. In the "ink breaking color" technique, color is literally broken with ink. First, paint the picture in color, and then cover it with ink when it is dry. This will result in a special spreading effect.

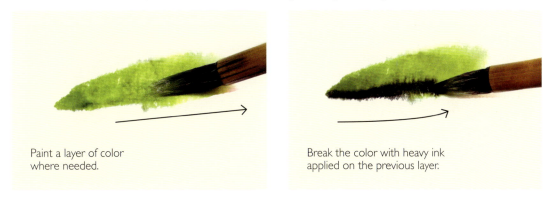

Paint a layer of color where needed.

Break the color with heavy ink applied on the previous layer.

Steps

1

Paint the peach blossom tree. Make the first stroke with *zhongfeng* plus a slight *cefeng*.

2

Add the branches with *zhongfeng*.

3

Refine the twigs.

CHAPTER TWO Spring Painting 39

4

Continue to refine the twigs.

5

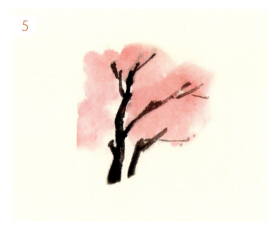

Blend eosin and clear water to the proportion of 3:7 to color the peach blossoms.

6

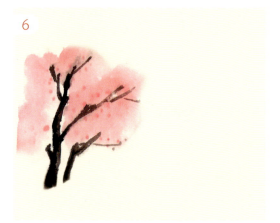

When dry, dot it with a mixture of water and eosin to the proportion of 1:9.

7

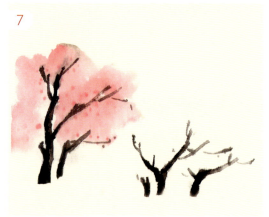

Add the branches of two more trees.

8

Repeat steps 5 and 6 to complete the peach trees.

9

Blend cyanine and gamboge to the proportion of 6:4 to make dark green; with *cefeng*, paint the embankment and part of the cabin. With *zhongfeng*, add the roof and fence to the cabin, and apply a little gamboge to the wall.

Add the rear embankment in dark green.

Add the peach trees on the rear embankment.

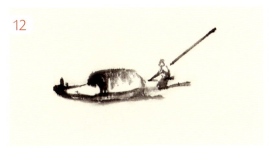
Sketch the fishing boat and fisherman in ink.

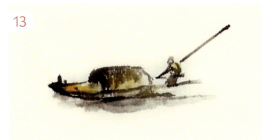
Blend gamboge and ocher to the proportion of 4:6 to color the canopy, hull, and fisherman.

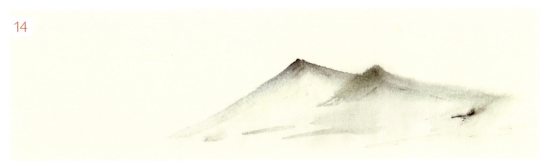
The distant scene requires lighter ink and color, plus a small amount of dark color to balance the picture. Use a large brush to paint the distant mountains with a very small amount of phthalocyanine blue mixed with clear ink.

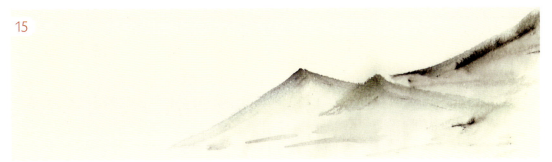
Refine the distant mountains. Use the "ink breaking color" technique to highlight the ridge.

CHAPTER TWO Spring Painting 41

16

Blend gamboge, head green, and light ink to the proportion of 3:5:2 to paint the river bank at the foot of the distant mountains.

17

Add the dark parts on the river bank with ink.

18

Add the peach trees on the river bank to complete the picture.

19

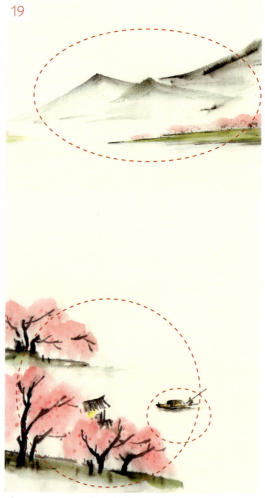

This picture uses a lot of *liubai* (leaving blank) to represent the water. Pay attention to segmentation in composition to unite the various parts of the scene.

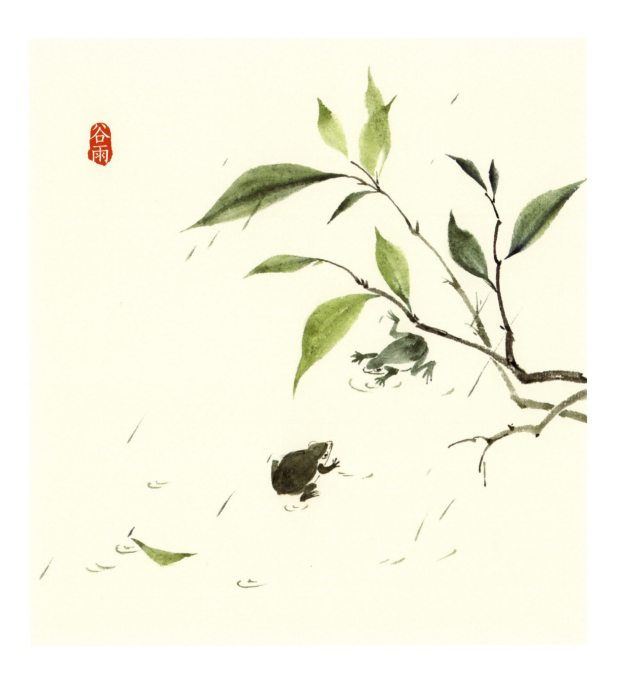

6. Grain Rain

Grain Rain is the last solar term in spring, falling between April 19 and 21, suggesting an increase in rainfall and grain growth. At this time, Chinese people pick special "grain rain" tea and appreciate peonies.

 The picture depicts two frogs playing in a deep green pond after a drizzle has cleaned and refreshed the leaves, blending perfectly in the bright spring scenery.

CHAPTER TWO Spring Painting 43

Colors

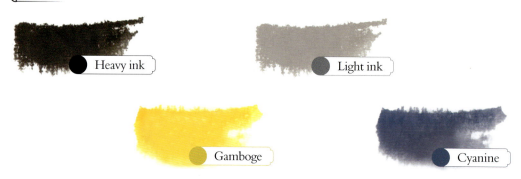

Painting Techniques

In addition to *zhongfeng* and *cefeng*, we will use "fast-slow" and "*ti-an*" (lift-press stroke) for different effects. We will now learn how to apply them in an integrated way.

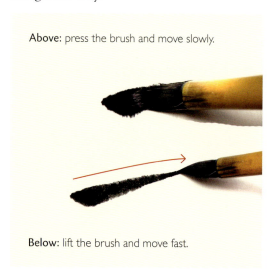

Above: press the brush and move slowly.

Below: lift the brush and move fast.

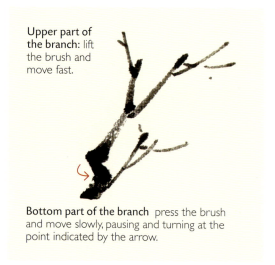

Upper part of the branch: lift the brush and move fast.

Bottom part of the branch press the brush and move slowly, pausing and turning at the point indicated by the arrow.

Steps

1

Blend cyanine and gamboge into green, and then blend green and light ink to the proportion of 7:3 to sketch the branch.

2

Continue to paint the forked branch, and add a small amount of heavy ink to pick out the twigs.

44 Chinese Brush Painting: Four Seasons

Add an appropriate amount of clear water to paint the second branch.

Reduce the proportion of ink to paint the thin branch at the back to display layers in the front and at the back.

Blend cyanine and gamboge to the proportion of 4:6 to paint the first stroke of a leaf.

Paint the second stroke to complete a leaf.

Add small leaves at the top and on the side.

Continue to add other leaves around it, with an increased proportion of cyanine for darker leaves.

CHAPTER TWO Spring Painting 45

Continue to add cyanine to paint the leaves on the right branch.

Blend gamboge, cyanine, and a small amount of light ink to paint the back and head of a frog.

Add its front and rear legs, and sketch its palm and sole with a detail painting brush.

Continue to sketch the outline of its belly and head with a detail painting brush, and then dot the eye.

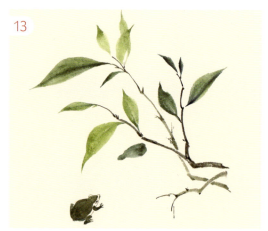

Dilute the color to paint the back and head of another frog in the same way. Two frogs are depicted face to face, to render a sense of fun and liveliness.

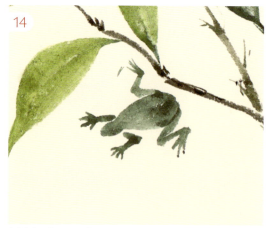

Add the front and rear legs of the frog, and sketch the palms and soles.

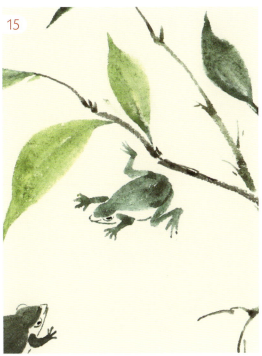

Sketch the belly and head with a detail painting brush, and then dot the eye.

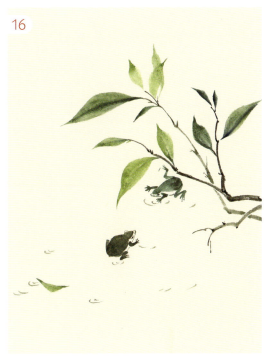

Use the color for the leaves in step 5 to paint a fallen leaf in the lower left corner. Then add a small amount of light ink to light cyanine to sketch the ripples produced by the raindrops.

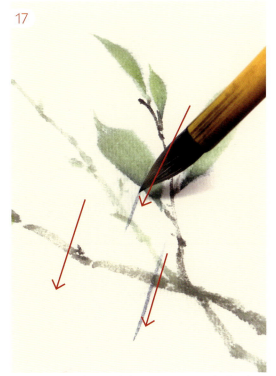

Depict the raindrops in light cyanine. Move the brush in the same direction to sketch the short lines.

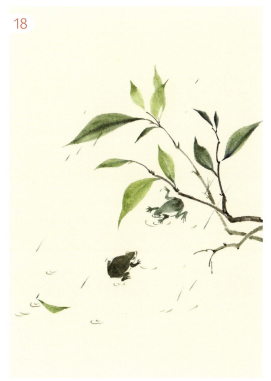

Paint more raindrops in the same inclined angle to complete the picture.

CHAPTER TWO Spring Painting 47

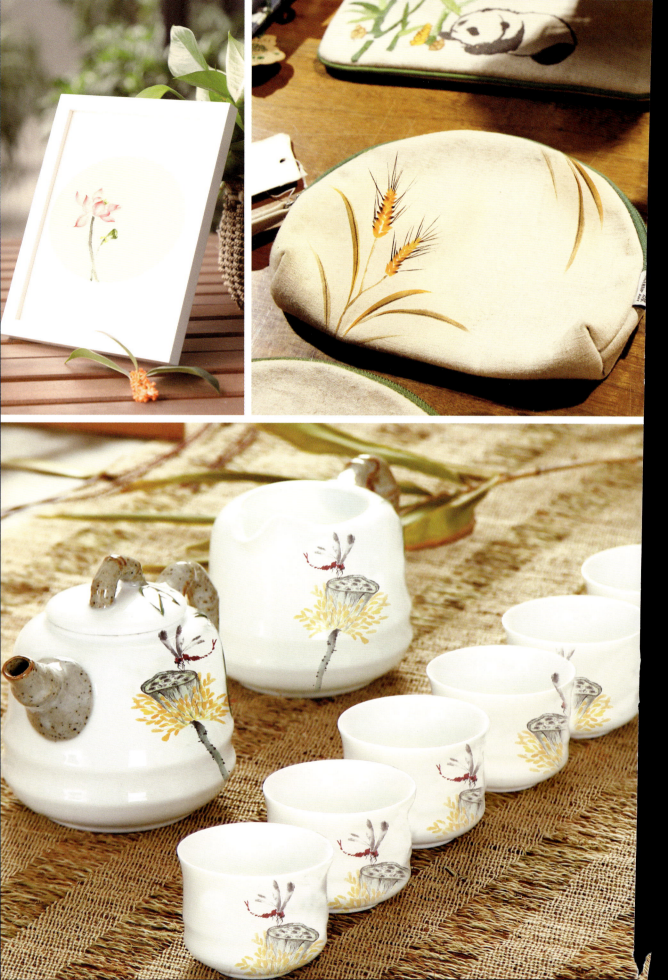

CHAPTER THREE
Summer Painting

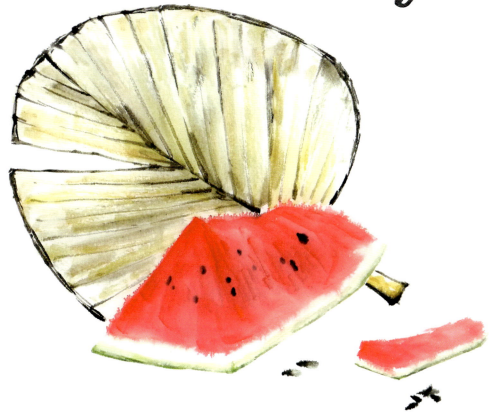

As the poem goes, "Spring sneaks away with the rain's incessant fall, which doesn't stop until summer's thrall."

The coming of summer brings bright sunshine, enticing chirping cicadas, blossoming flowers, and verdant fruits and vegetables. Nature displays itself in all of its incredible variety and vitality.

In this chapter, we will present the solar terms from Beginning of Summer to Major Heat, with paintings that cut a cool breeze through the searing days. Before we start painting, we need to understand what is to be depicted, and the form of expression. Beforehand, it is advisable to observe the shape and posture of natural creatures such as flowers and insects, so that twice as much work can be accomplished with half the effort.

On facing page
Fig. 12 The application of ink painting on a decorative item, a purse, and a tea set.

Fig. 13 Cattail leaf fan and watermelon.

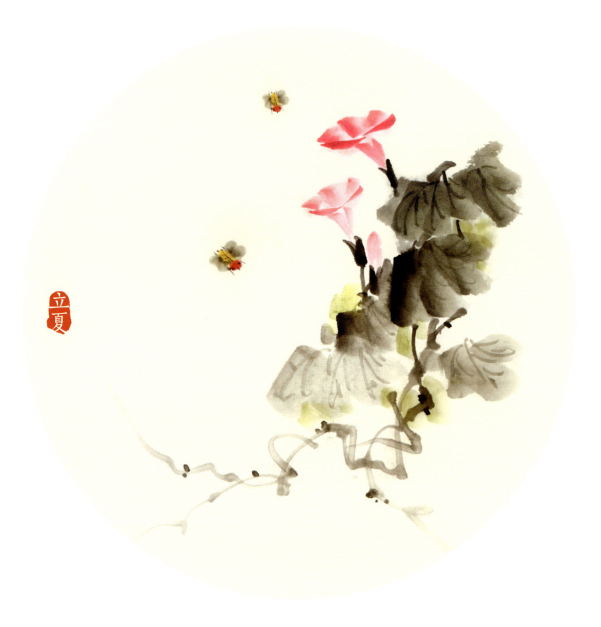

1. Beginning of Summer

The first solar term of the summer, falling between May 5 and 7, marks the arrival of the summer season. At this time, abundant sunshine and rain prompt all creatures to prosper.

 At the Beginning of Summer, the morning glory is in full bloom, as bright as a trumpet. This picture depicts two peach-pink morning glories, luring two bees to their nectar with their tempting fragrance. The spread of the flowers and leaves and the crisscross of the vines create a simple yet attractive scene.

Colors

Heavy ink

Light ink

Eosin

Gamboge

Cyanine

Painting Techniques

To display larger leaves in freehand brushwork, a commonly used technique is "ink splash." This method is used for lotus leaves and other objects that occupy a large area of the picture. It involves not directly pouring ink onto the paper, but dipping a water-soaked brush into the ink and building a dripping effect.

Dip the tip of the water-soaked brush hairs into the ink.

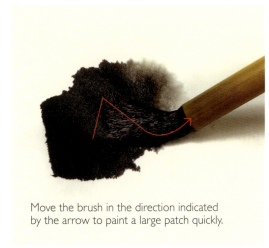

Move the brush in the direction indicated by the arrow to paint a large patch quickly.

Steps

1

Paint the morning glory. Segment the trumpet-shaped flower into petals to make a three-dimensional conical shape. Paint the first petal in eosin.

2

Add the second stroke to paint the second petal.

3

Paint the third petal immediately on top of the first petal with *cefeng*.

CHAPTER THREE Summer Painting 51

4	5 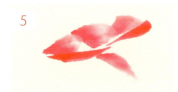	6 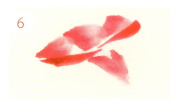
Paint the fourth petal to the right of the third with *cefeng*.	Paint the fifth petal in the same way, and add the receptacle beneath the flower.	Add a second stroke to complete the receptacle.
7 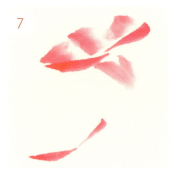	8 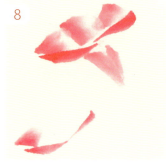	9 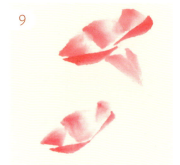
Paint the second flower at the bottom left of the first.	Continue to add petals.	Complete the flower head.
10	11	12
Add the receptacle.	Add the bud to break the parallel layout.	Add the stalk in heavy ink.

13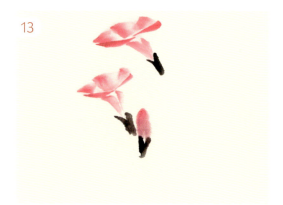

Refine the stalks of the flowers and bud.

14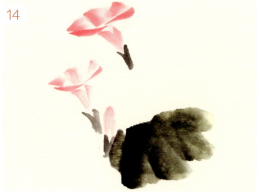

Blend cyanine, gamboge, and ink to the proportion of 2:2:6 to paint the leaf, in a color darker than that of the flowers, so that the overall picture presents a contrast of depth, with the color of the leaves in varying shades.

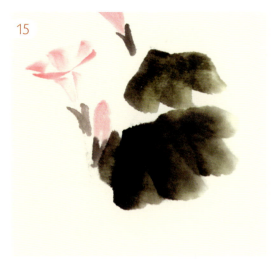

Add one more leaf.

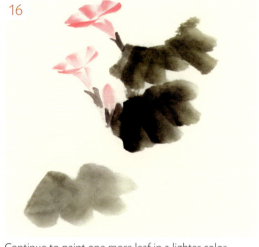

Continue to paint one more leaf in a lighter color.

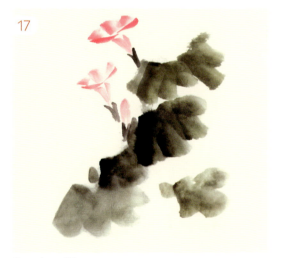

Complete all leaves.

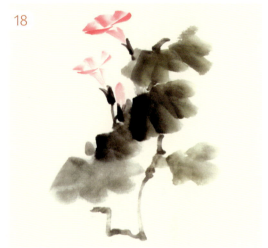

Sketch the main part of the vine with *zhongfeng*.

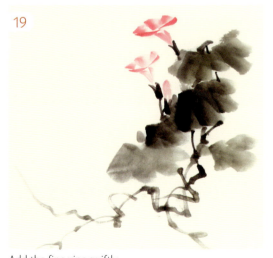

Add the fine vine swiftly.

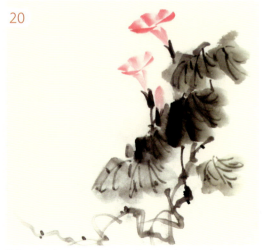

When the leaves are almost dry, sketch the veins.

CHAPTER THREE Summer Painting 53

21

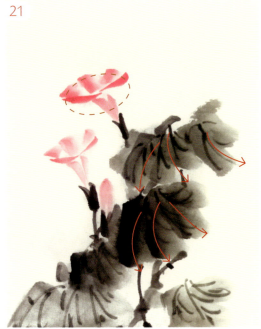

22

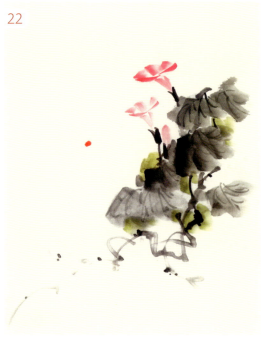

When painting the morning glories and leaves, the flowers should be painted in the shape of a horn, in a three-dimensional cone shape as a whole, while the leaves are in an inverted claw shape. Make sure the strokes are connected when moving the brush.

Blend gamboge and cyanine into yellowish green to dot between the leaves to add dimensions to the picture. Finally, paint the bee. On the left side of the picture, paint the head in eosin.

23

24

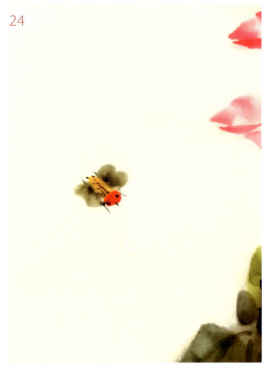

Paint the body in gamboge and the wings in light ink.

Sketch the details of the bee in heavy ink, and add a second bee at the top in the same way to complete the picture.

54 Chinese Brush Painting: Four Seasons

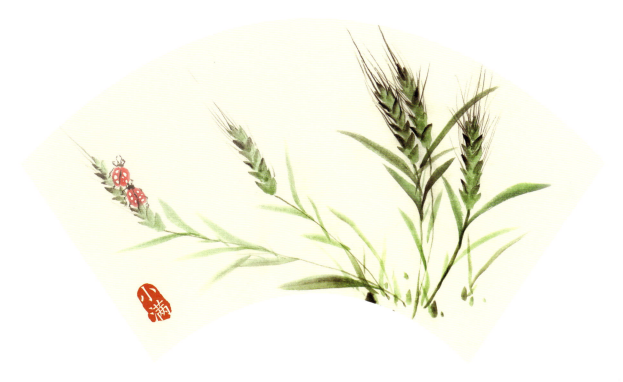

2. Grain Buds

Grain Buds is the second solar term in summer, falling between May 20 and 22, when the seeds of summer crops begin to grow in full, but are not yet fully mature amidst the frequent rainfall and rising temperatures.

The picture depicts a cluster of green wheat. The fruits in the ears of wheat are almost full, luring two ladybugs eager to explore, as if they intended to taste the joy of the harvest in advance. Their red shells are particularly conspicuous among the green wheat ears, balancing the structure of and adding vitality to the picture.

Colors

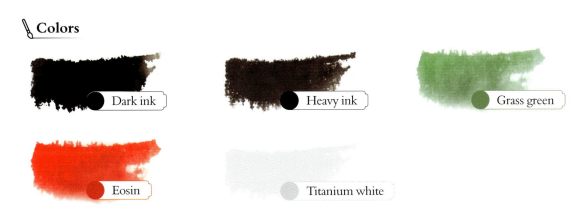

CHAPTER THREE Summer Painting

Painting Techniques

As well as expressing the shape of an object with the traditional combination of strokes, the pressing method can directly outline the shape of an object by dint of the characteristics of the brush. Start with *zhongfeng*, and swiftly press and lift the brush to express the outline of an object. The traditional *xieyi* (freehand) method turns to the combination of the changing strokes, while the pressing method starts with *zhongfeng* and presses and lifts the brush swiftly to sketch the outline of the object.

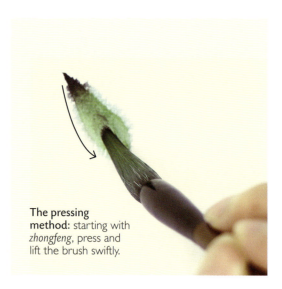

The pressing method: starting with *zhongfeng*, press and lift the brush swiftly.

Steps

1. Paint the ears of wheat using the pressing method. Dip the belly of the brush into grass green and the tip in heavy ink, and dot the first grain of wheat starting with *zhongfeng*.

2. Dot the second and third wheat ears in turn, being mindful of the relative positions of the wheat ears.

3. Dot downward to create more ears of wheat.

4. Finish painting the first sheaf of wheat ears.

5. Paint the second and third sheaves in the same way.

6. Add a sheaf of wheat ears to the left.

7

Add a sheaf of wheat ears on the far left, leaving space for the ladybugs. Complete the overall layout of the wheat ears.

8

Add whiskers to the wheat ears using fine strokes.

9

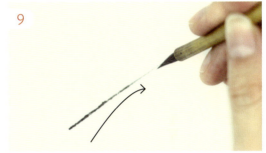

When painting the wheat whiskers, dip the tip of a small brush into heavy ink, then carefully and swiftly sketch with a solid starting stroke and a soft closing stroke.

10

When finishing the whiskers, paint the straw with *zhongfeng*.

11

Paint the leaves in the same color as the ears of wheat.

12

Continue to add leaves.

13

Finish painting the leaves, which are lighter in color than those on the right, to display varying shades.

CHAPTER THREE Summer Painting 57

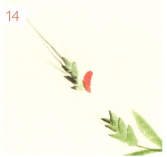
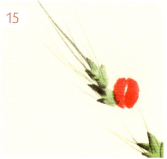
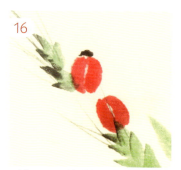

14 When painting the ladybugs, be mindful of their proportion compared with the wheat ears. When painting the details of the head and legs, use a small brush to sketch with not too much water. First paint the first stroke of the ladybug's body in eosin.

15 Add the second stroke to complete the body.

16 Add a second ladybug. Add the first stroke of the head to the first ladybug in heavy ink.

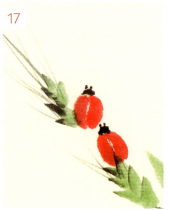
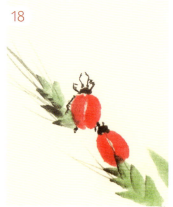
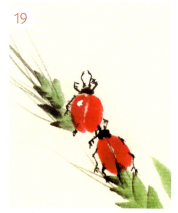

17 Add two ink dots to the head of the ladybug as the eyes in heavy ink. Complete the head of the second ladybug in the same way.

18 Add the feet and antennae of the ladybugs in heavy ink.

19 Dot the spots on the back of the ladybug in thick titanium white.

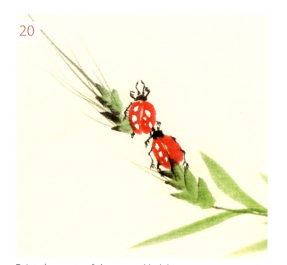
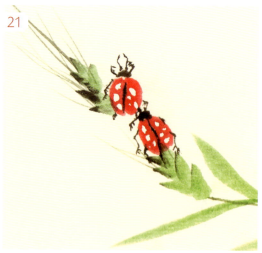

20 Paint the spots of the second ladybug.

21 Refine the details. The picture is now complete.

58 Chinese Brush Painting: Four Seasons

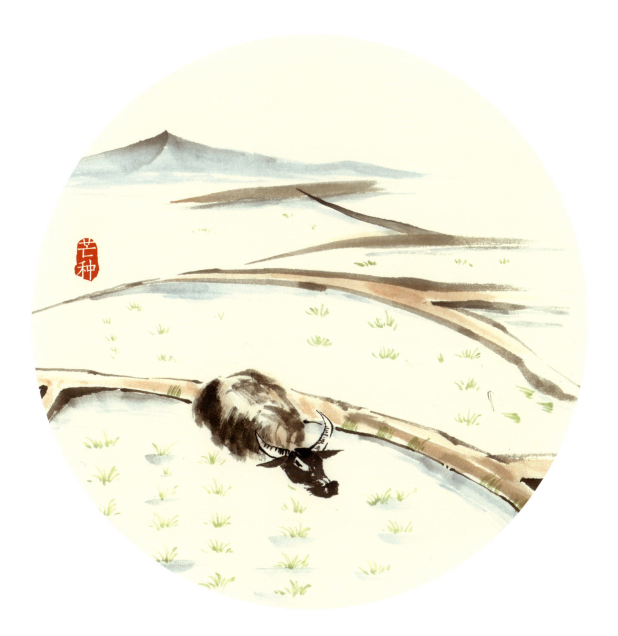

3. Grain in Ear

Grain in Ear is the third solar term of the summer, falling between June 5 and 7, and signifying the beginning of midsummer. At this time, the temperature rises significantly and rainfall is abundant, marking another season of farming activity.

 The picture depicts a paddy field where rice seedlings have just been planted. An ox is resting at ease in the water after work. This creature has long played a key role in China's 5,000-year-long agricultural civilization, as a helper to farmers. As well as being one of the twelve zodiac animals, the ox is a symbol of diligence.

Colors

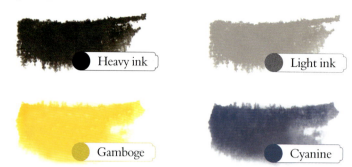

Heavy ink

Light ink

Ocher

Gamboge

Cyanine

Painting Techniques

We have learned the "ink breaking color" method, and will now look at another two "broken ink" techniques, i.e., "dark breaking light" and "light breaking dark," understanding the differences between them through comparison. The "broken ink" method produces a variety of effects by using different inks in succession. "Dark breaking light" will produce the effect of ink spreading, while "light breaking dark" will not taint the previous strokes of dark ink.

Dark breaking light: adding dark ink on top of light ink for a spreading effect, which will taint the stroke of light ink.

Light breaking dark: adding light ink onto dark ink. The stroke is clear.

Steps

1

Dip your brush in heavy ink, shift from *zhongfeng* to *cefeng*, and paint the head of the ox.

2

Paint the nose with *cefeng*, and sketch the bridge of the nose.

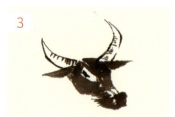

3

Shift from *zhongfeng* to *cefeng* to paint the ears with a closing *zhongfeng*, and sketch the horns and eye.

60 Chinese Brush Painting: Four Seasons

4	5	6
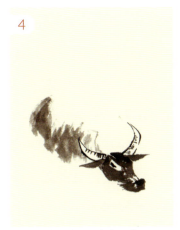	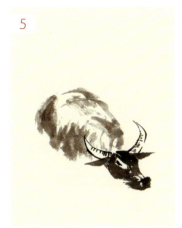	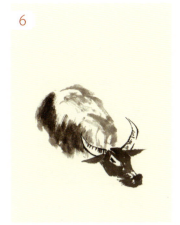
Brush with *cefeng* in light ink to paint the left side of the back.	Paint the right side of the back with the same strokes.	Dip your brush into heavy ink and overlay the dark part of the left side of the back to complete the ox.

7	8
Paint a horizontal Y shape in light ink to sketch the ridge of the field.	Paint a Y-shaped ridge on the right in light ink in the same way.

9	10
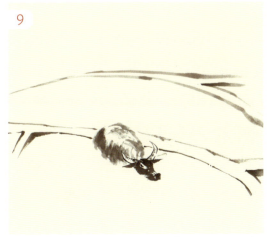	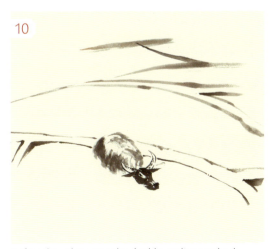
Dilute the ink with a small amount of water to paint the ridge a little further away.	Refine the ridge using the double-outline method.

CHAPTER THREE Summer Painting

11

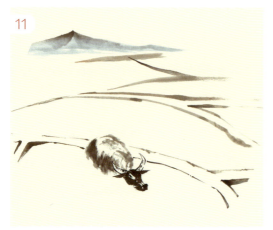

Dip your brush into cyanine and light ink to color the distant mountain.

12

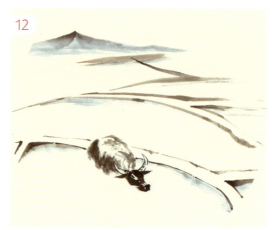

Blend cyanine and light ink to the proportion of 4:6, and paint the shadow below the ridge of the field with *cefeng*.

13

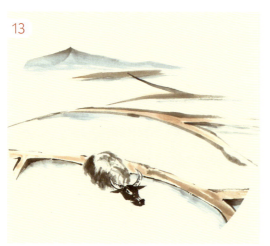

Color the ridge in ocher.

14

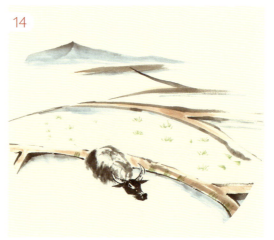

Blend cyanine and gamboge to the proportion of 3:7 into emerald green to sketch the seedlings.

15

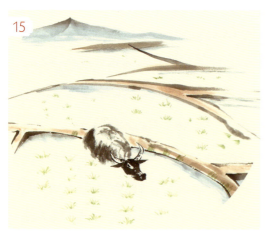

Paint more seedlings and add distant ones. Be mindful of the differences in size between the near and far seedlings.

16

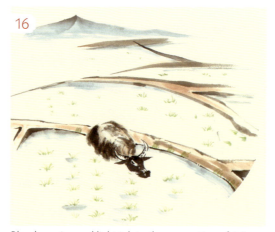

Blend cyanine and light ink to the proportion of 4:6, and dilute it with water to paint the reflection of the seedlings. The picture is now complete.

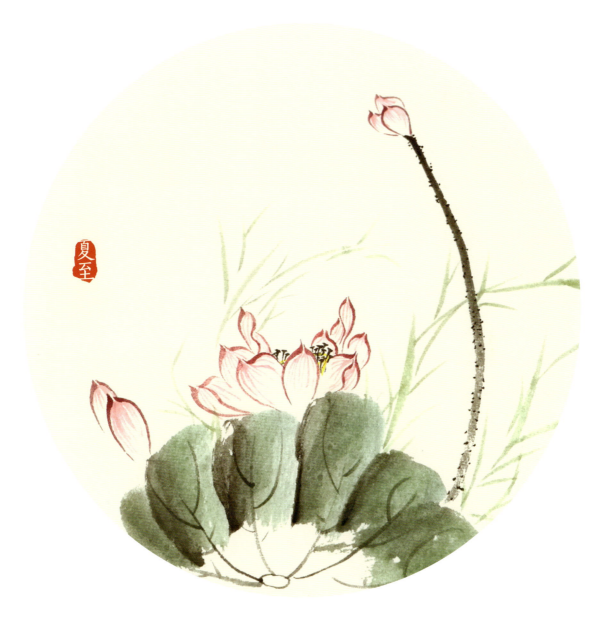

4. Summer Solstice

Summer Solstice is the 10th of the 24 solar terms, falling between June 21 and 22, when the sun is at its highest position of the year. With the increasing temperatures, humidity, and thunderstorms after Summer Solstice, the plum rain season sets in at the middle and lower reaches of the Yangtze River in China.

The lotus depicted in the picture is one of the top ten renowned flowers in China, blossoming in summer. Commonly seen in courtyards, paintings, arts and crafts, it is cherished by scholars and men of letters of all ages due to

its nobility, after coming out of the mud without being tainted. Wei Yingwu (c. 737–791), a prominent poet of the Tang dynasty (618–907), wrote a poem depicting a pleasant summer scene of a fragrant lotus pond that he passed on an outing on Summer Solstice.

Colors

Painting Techniques

When painting birds and flowers in the freehand style, dotting stamens can be taken as the final touch. Two commonly used techniques for dotting stamens in freehand paintings are to dot the stamens in heavy ink as if writing, and to dot directly in a darker and thicker color.

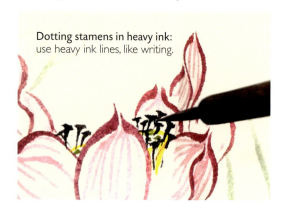

Dotting stamens in heavy ink: use heavy ink lines, like writing.

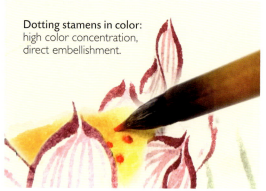

Dotting stamens in color: high color concentration, direct embellishment.

Steps

1

Paint the leaves of the lotus. Blend head green with ink to paint the leaf.

2

Add the strokes to the right in the same color.

3

Paint six strokes in total to complete a lotus leaf.

64 Chinese Brush Painting: Four Seasons

4

When it is dry, sketch the veins of the lotus leaf.

5

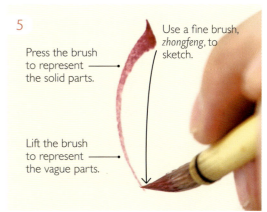

Press the brush to represent the solid parts.

Lift the brush to represent the vague parts.

Use a fine brush, *zhongfeng*, to sketch.

Sketch the lotus in double-outline method. To highlight the layers, paint the petals with the pressing and lifting method to represent different shades of color and the solid and vague parts.

6

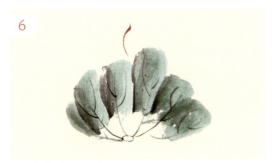

Sketch the first stroke in eosin.

7

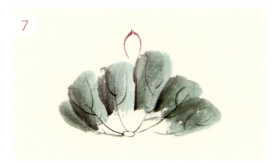

Sketch the second stroke to paint a petal.

8

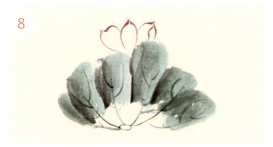

Add petals to both sides.

9

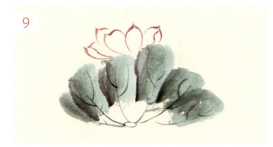

Continue to add petals. Note that the petals are radial as a whole.

10

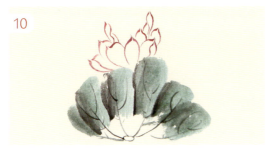

Continue to enhance the petals.

11

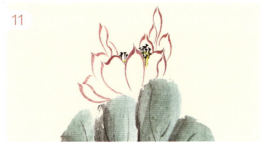

Embellish the stamens in gamboge and enhance the center in heavy ink.

CHAPTER THREE Summer Painting 65

12

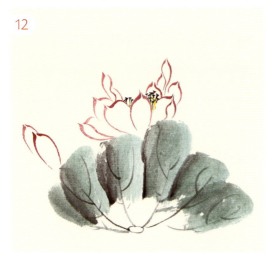

Add two petals to the left of the lotus leaf.

13

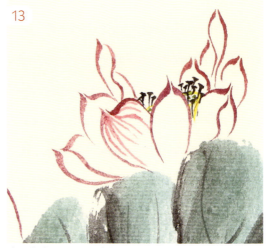

Sketch the texture of the petals' surface in eosin.

14

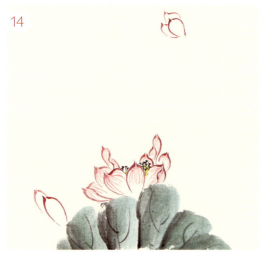

Add a lotus bud on the top right.

15

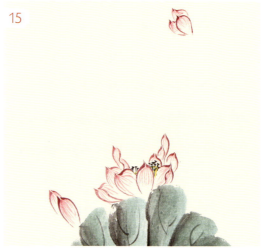

Enhance the surface texture of all petals in eosin.

16

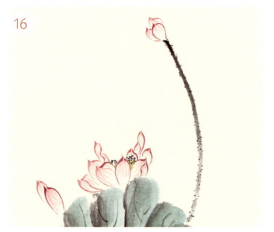

Dip the tip of your brush in heavy ink and the belly in light ink to paint the branch in one stroke, and dot small thorns on the branch.

17

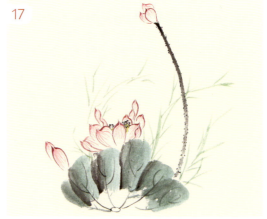

Blend cyanine and gamboge to the proportion of 5:5 to refine the water grass. The picture is now complete.

Chinese Brush Painting: Four Seasons

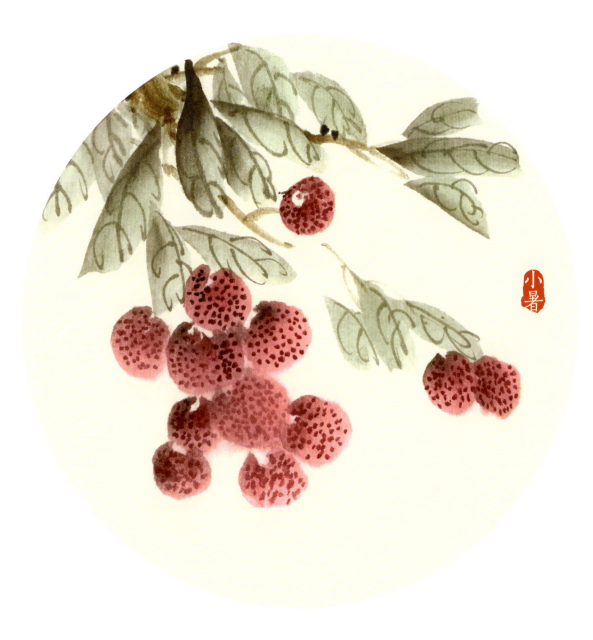

5. Minor Heat

Minor Heat is the eleventh solar term of the year, falling between July 6 and 8, when the weather gets hotter but summer is not yet in full swing.

 This picture depicts lychees—a fresh, sweet, and juicy fruit that has been cultivated for thousands of years in China, and is one of the most popular summer fruits. The hard shell is peeled off to reveal white crystalline flesh that has a lingering flavor. The concubine Yang Guifei (719–756)—one of the four classic beauties of Ancient China—was particularly fond of lychees,

so the emperor had them delivered to her on fast horses crossing thousands of miles. The lychees in this picture hang heavily on the branches, ripe and ready to be picked.

Colors

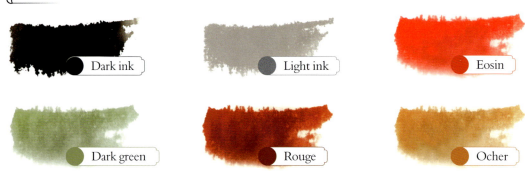

Painting Techniques

The strokes of Chinese painting vary constantly when in actual use, such as the technique of turning with *cefeng* in this part when painting round objects such as fruit and vegetables. Paint the shape of the lychee by turning with *cefeng*, which involves two steps: pressing the brush slowly, and then turning to paint a half arc followed by a second half arc.

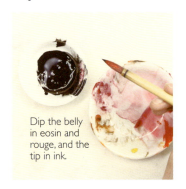
Dip the belly in eosin and rouge, and the tip in ink.

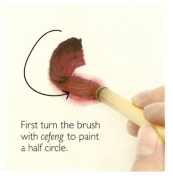
First turn the brush with *cefeng* to paint a half circle.

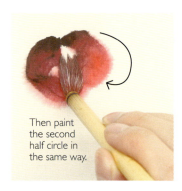
Then paint the second half circle in the same way.

Steps

1

Paint the leaves and branches. First paint the leaves as a whole, and then connect the scattered leaves with the branches to balance the picture. Dip the brush tip in ink and the belly in dark green; shift from *zhongfeng* to *cefeng* to paint the first leaf.

2

Paint the first set of leaves in the same way.

3

Immediately beneath the first set of leaves, paint the second set of leaves.

4

Continue to add a set of leaves to the right.

5

Dip the brush in light ink and dark green to continue adding leaves, and note the change in intensity.

6

Complete all the leaves in the picture.

7

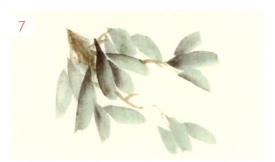

Blend ocher and ink to paint the branches.

8

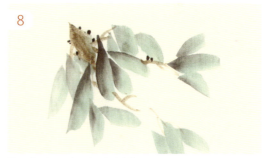

Dot the branches in dark ink.

9

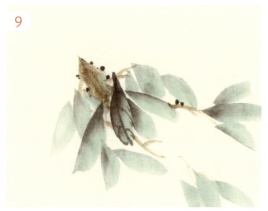

Sketch the veins of the leaves.

10

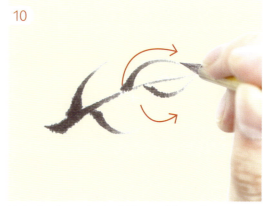

Note the change in the thickness of lines when sketching the leaf veins. The leaf veins are depicted with nail-head rat-tail lines, and the thickness of the lines must be noted. Nail-head rat-tail lines are a kind of line painting, starting like a nail head and closing like a rat tail. You need to *dun* (pause) when starting, and lift the brush slowly while closing.

CHAPTER THREE Summer Painting 69

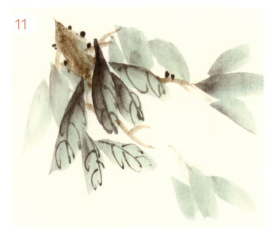

Continue to sketch the leaf veins, noting that they should be painted in a downward direction.

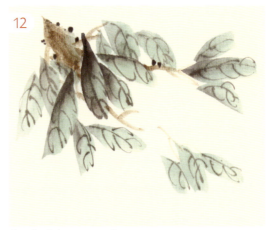

Sketch all the veins in the same way.

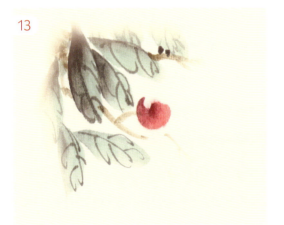

Now paint the lychees. It is a fruit with relatively simple structure. Note that the brush should not absorb too much water. Use the technique of turning with *cefeng* to paint the left half of the lychee, blending eosin and rouge (a little more rouge than eosin).

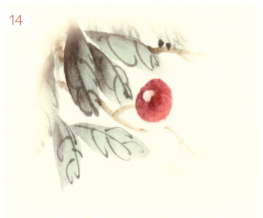

Add the right half and finish the first lychee.

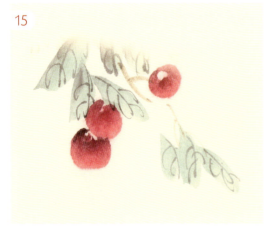

Add two lychees next to each other beneath the first one in the same way.

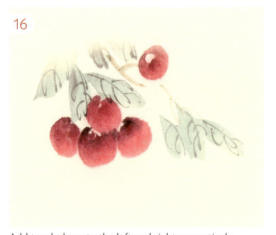

Add two lychees to the left and right respectively.

17

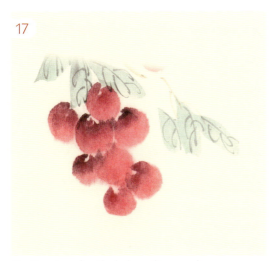

Continue to refine the lychees downward.

18

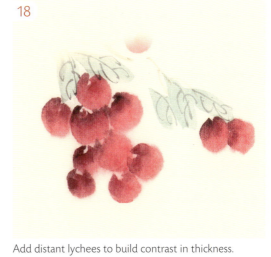

Add distant lychees to build contrast in thickness.

19

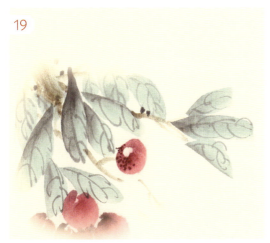

Blend rouge with ink to dot the first lychee to give the impression of scaled skin.

20

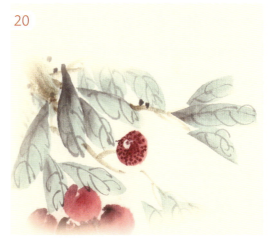

Dot the lychee with rouge ink to complete the first lychee.

21

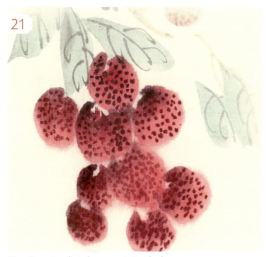

Continue to dot the remaining lychees.

22

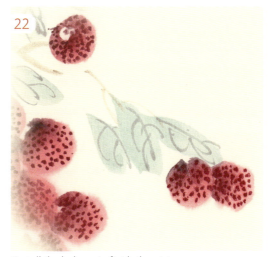

Dot all the lychees to finish the picture.

CHAPTER THREE Summer Painting 71

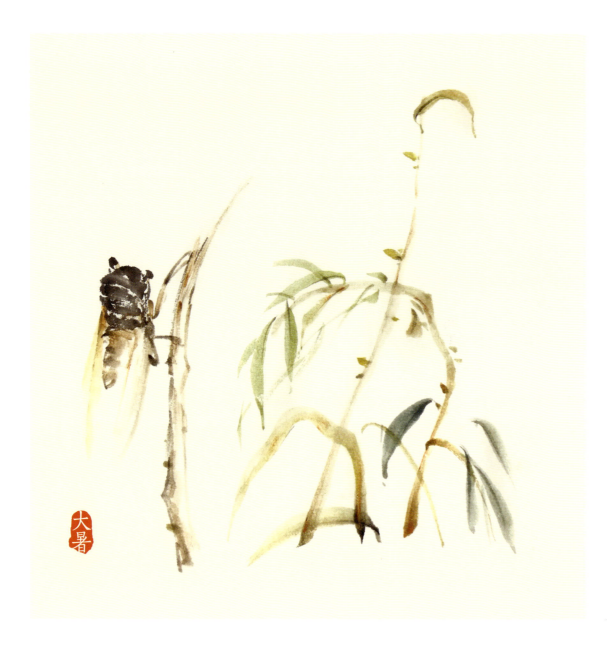

6. Major Heat

Major Heat is the 12th of the 24 solar terms, falling between July 22 and 24, which is the hottest time of the year. At this time, under the lush shade of trees, cicadas chirp nosily.

 This picture depicts a midsummer scene. A summer cicada lies recuperating on the scorched grass, languid and listless. The cicada has rich connotations in Chinese culture. Because of the changes in its shell, it is endowed with the moral of being reborn and the character of honesty and uprightness. It is often depicted in paintings and poems, or used in decorations to express good wishes.

Colors

Dark ink

Light ink

Gamboge

Cyanine

Ocher

Painting Techniques

We have learnt the technique of "ink splash." Here, we will learn the "dipping ink" method. The color change in the "dipping ink" strokes renders a three-dimensional feeling, so it is often used to depict orchids and bamboo in *xieyi* (freehand) style. The "dipping ink" method involves dipping the tip into dark ink with the hairs already in the proper color to give perspective, with the ink color of the strokes clearly presented in shades.

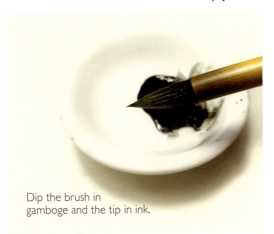
Dip the brush in gamboge and the tip in ink.

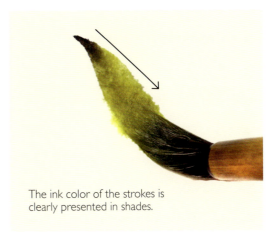
The ink color of the strokes is clearly presented in shades.

Steps

1

2

3

Paint the cicada. Its head contains the heaviest color of the picture. When painting, note the gap between the strokes to make sure they are not too far apart, but not clustered together. Paint the first stroke with *cefeng* in heavy ink.

Paint the second stroke to the right from the bottom left of the first stroke.

Paint the third stroke to the left from the bottom right of the first stroke.

CHAPTER THREE Summer Painting 73

4 Add the fourth stroke with *cefeng*.	5 Continue to move downward to add texture to the head.	6 Add the details of the head to the right.	7 Paint the eyes.
8 Sketch the abdomen and tail in ocher.	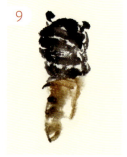 9 Refine the shape of the abdomen and tail.	10 Start painting the wings. As the cicada's wings are thin and transparent, the color needs to be relatively light. Apart from directly depicting the wings in ink, we can sketch the outline first, and color the inside from thick to light.	
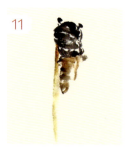 11 Blend ocher and a small amount of gamboge to sketch the outline of a wing.	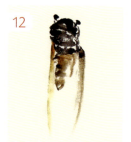 12 Add the outline of the other wing.	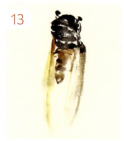 13 Dilute the color with a small amount of water to color the wings in light color.	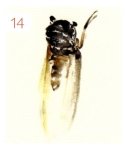 14 Add the feet.
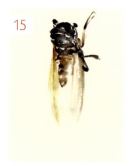 15 Continue to add the feet.	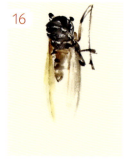 16 Blend ocher with light ink to the proportion of 7:3, and sketch the branch next to the feet with *zhongfeng*.	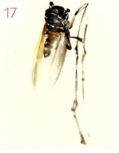 17 Paint the branch with the double-outline method.	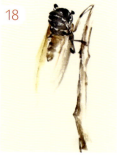 18 Color the inside of the branch.

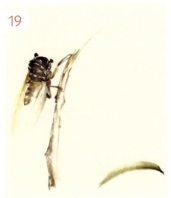

19

Dip the belly of your brush in the blend of ocher and gamboge, and dip the tip in heavy ink. Add the leaf on the right side of the picture with *cefeng* and close with *zhongfeng*.

20

Blend ocher and gamboge to add the second leaf. Note that apart from the cicada, the branches and leaves are colored towards yellow to highlight the characteristics of the solar term.

21

Use *zhongfeng* to sketch the branch.

22

Paint dots on the branch.

23

Add a second branch. Note the thickness of strokes.

24

Blend gamboge and cyanine into green to paint the leaves.

25

Refine the fresh leaves and paint twigs beneath them.

26

Add two branches at the bottom right, and then add the leaves at the bottom right in green composed of more cyanine. The picture is now complete.

CHAPTER THREE Summer Painting 75

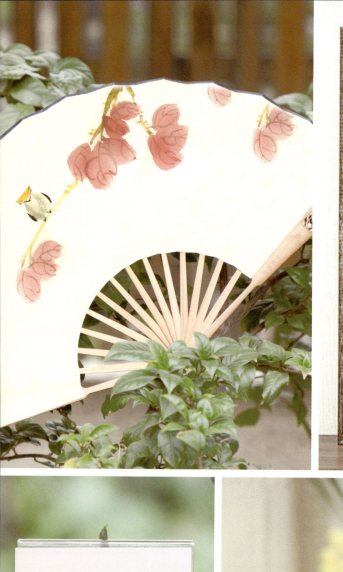

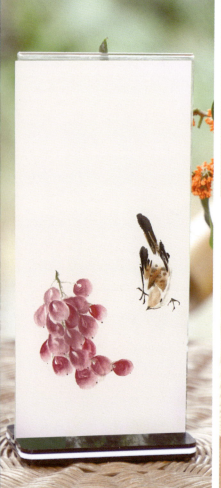

CHAPTER FOUR
Autumn Painting

As the poem states, "A grain of millet planted in spring, means ten thousand seeds harvested in autumn." Autumn is a harvest season laden with heavy fruits. It is an ideal time to travel to the mountains and rivers to enjoy the kaleidoscopic scenery of this invigorating season.

In this chapter, we will depict fruits and natural scenery representing the solar terms from Beginning of Autumn to Frost's Descent, to render the strong harvest flavor and unique autumnal beauty. To represent the autumn solar terms, we need to focus on the overall coloring to highlight the distinct seasonal features. Before you start, make some observations of nature in autumn.

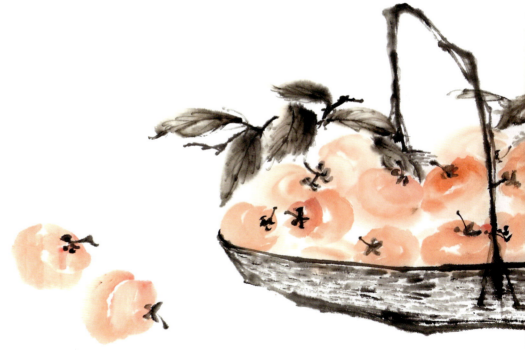

On facing page
Fig. 14 The application of ink painting on a folding fan, a decorative picture, a display board, and vases.

Fig. 15 Persimmons in the basket.

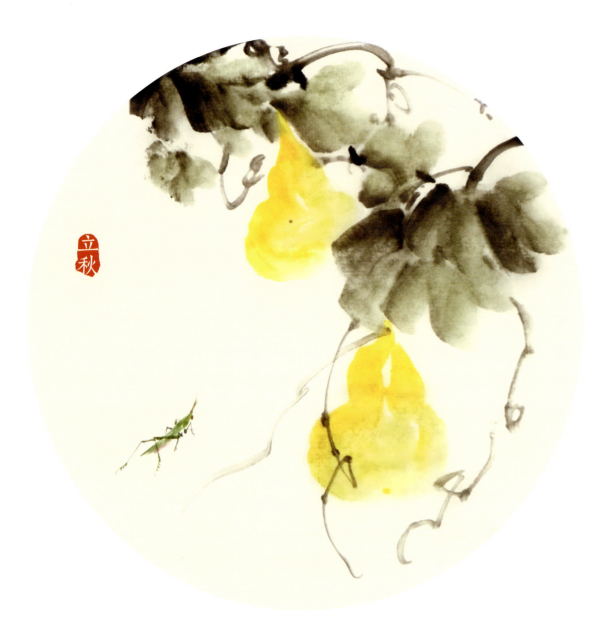

1. Beginning of Autumn

Beginning of Autumn is the first solar term of the autumn, falling between August 7 and 9, and indicating the cooling of the weather. However, across China's vast territory, the climate varies greatly, with many areas hotter at the beginning of autumn than summer.

Autumn is also a harvest season. The golden gourd depicted in this picture is huge and full, ready to be eaten. A small grasshopper is looking up at it, mouthwatering. In Chinese culture, the gourd is a common image in

78 Chinese Brush Painting: Four Seasons

literature, art, folklore, myths, and legends because its pronunciation is close in pinyin to *fu* (happiness) and *lu* (fortune), carrying the auspicious meaning of wealth and longevity.

Colors

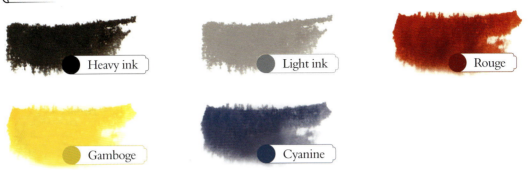

Painting Techniques

In Chinese painting, the tip and the belly of the brush are used primarily, but the heel matters as well. Here we will learn the "full wipe" stroke technique, which uses the heel of the brush to paint large patches, such as the gourd fruit in this section.

To achieve the desired effect, start with *zhongfeng*.

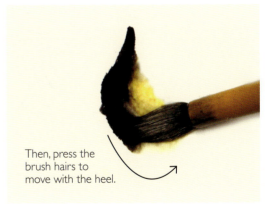

Then, press the brush hairs to move with the heel.

Steps

1

Paint the leaves. Blend cyanine, gamboge, and ink to the proportion of 2:2:6 into dark green to paint with *cefeng*.

2

Continue to complete the first group of leaves with *cefeng*.

CHAPTER FOUR Autumn Painting 79

3

Beneath the first group of leaves, paint the second group.

4

Complete the second group. Be mindful of the variation in color. The leaves added later should be lighter in color.

5

Add small leaves to the top left of the first group of leaves.

6

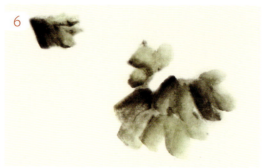

Add the third group of leaves on the left side of the picture.

7

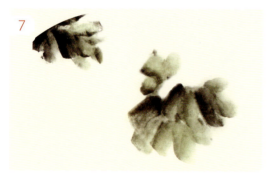

Increase the number of leaves to make them fuller.

8

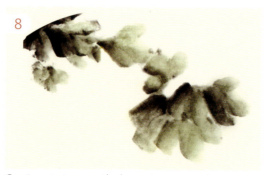

Continue to increase the leaves to connect those on both sides of the picture as a whole.

9

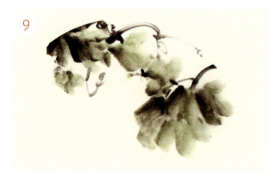

Add the main branch in heavy ink.

10

The gourd is a vine plant, and has twining vines. When painting, use a fine brush to work quickly, like writing.

80 Chinese Brush Painting: Four Seasons

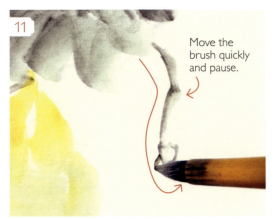

Sketch the vines with *zhongfeng*. When moving your brush, use a quick stroke and pause alternately. The point indicated by the arrow is where to pause.

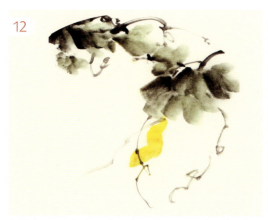

Add the gourd when the ink on the vine is dry. Sketch the outline of the gourd with the blend of gamboge and water at 5:5.

Refine the shape of the gourd with full wipe stroke.

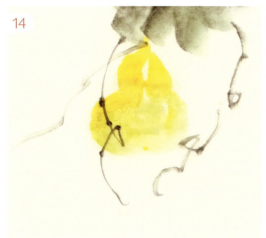

Repeat steps 12 and 13 to complete the other half of the gourd.

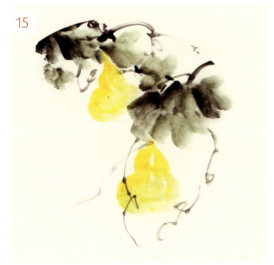

Add a second gourd in the same fashion.

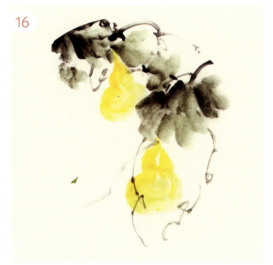

Add a grasshopper on the left side of the picture.

CHAPTER FOUR Autumn Painting

17

The grasshopper should not be too green, but more towards gamboge, as the yellowish green matches the overall hue of the picture. Blend gamboge and cyanine at 4:6 into green to sketch the body of the grasshopper.

18

Sketch a stroke in light rouge to express its abdomen, and sketch a pair of its forefeet in the blended green with ink.

19

Add the second pair of feet.

20

Add the two rear feet.

21

Blend rouge and gamboge at 8:2 to refine its antennae and eye.

22

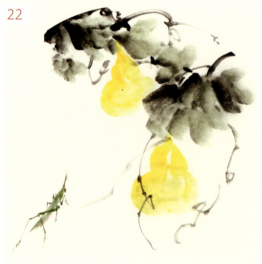

The picture is now complete.

82 Chinese Brush Painting: Four Seasons

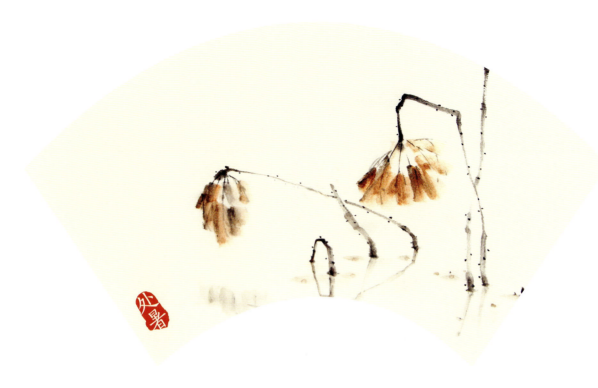

2. End of Heat

End of Heat, the 14th of the 24 solar terms, falls between August 22 and 24, and is a transitional period from heat to cool, marking the end of the searing summer. At this time, local customs involve floating river lanterns, eating duck, and splashing water.

　　Autumn is golden in most people's minds. Only the gilded leaves of the pink lotuses of midsummer now remain. In the previous chapter, we learned how to paint a summer lotus. Now we will learn how to present the texture of withering lotus branches and leaves to appreciate the distinctive beauty of the cool autumn.

Colors

Heavy ink

Light ink

Ocher

Painting Techniques

The End of Heat atmosphere can be expressed with brush strokes. In painting, the *xieyi* (freehand) stroke expresses different textures through variations in wetness. A dry brush contains less water, and the strokes are hollow and dry, making it ideal to depict a dry texture. A wet brush contains more water, and the strokes are round, making it suitable to depict a wet texture.

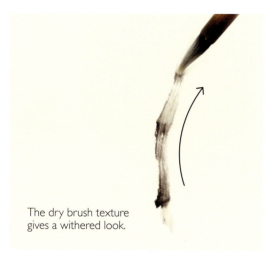

The dry brush texture gives a withered look.

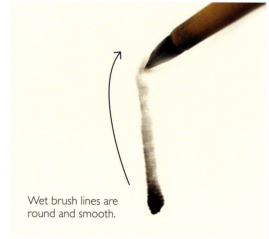

Wet brush lines are round and smooth.

Steps

1

Use a dry brush to sketch the remaining stems of the lotus. First, dip the hairs of the brush in light ink and the tip in heavy ink, and use *zhongfeng* and a dry brush to sketch a stem.

2

Paint a second stem crossing the first.

3

Continue to add a third stem with *zhongfeng*.

4

Blend ocher and ink at 9:1 to paint the leaf.

84 Chinese Brush Painting: Four Seasons

5	6
	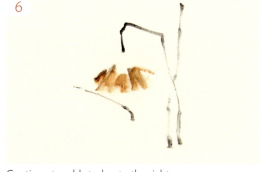
Add more strokes to the right of the leaf.	Continue to add strokes to the right.

7	8
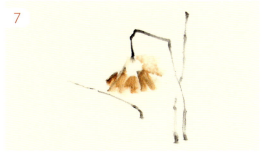	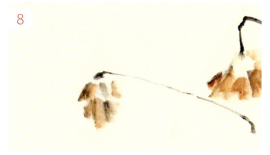
Blend ocher and water at 3:7 to continue adding the strokes to the leaf.	Dip the belly of the brush in the diluted ocher in the previous step, and dip the tip in light ink to add the second leaf on the left side of the picture.

9	10
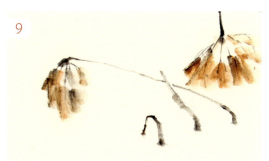	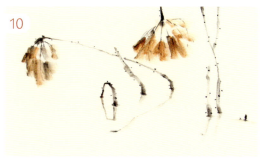
Add two withered stems beneath the leaves, and sketch the veins of two withered leaves in ink to enhance the picture.	Blend light ink and ocher at 9:1 to add the reflection of the stems, and dot the thorns on the stems in heavy ink.

11	12
	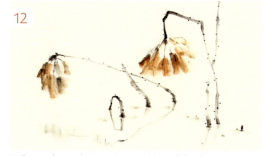
To clearly show the dividing line of the water surface (the point indicated by the arrow), use a "full wipe" stroke to highlight the water surface.	Refer to the technique in step 11, and dip the water-soaked brush in ocher to paint the water surface to complete the picture.

CHAPTER FOUR Autumn Painting

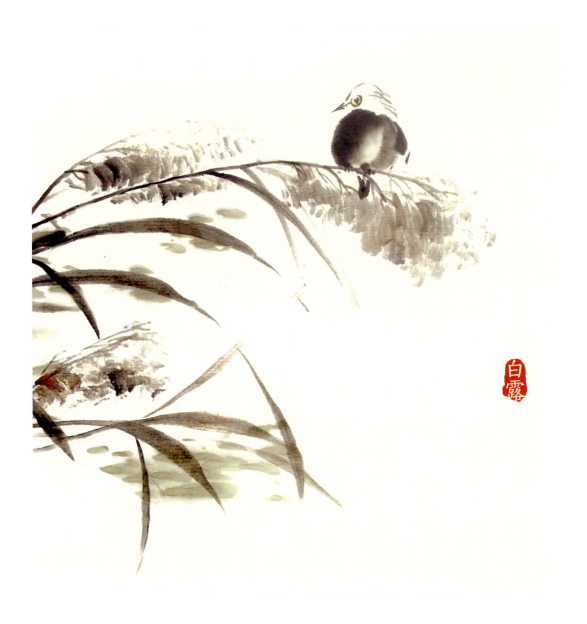

3. White Dew

White Dew is the 15th of the 24 solar terms, falling between September 7 and 9, when there is a large temperature difference between day and night. At this time, migratory birds begin to fly southward for winter, and other birds begin to store fruit.

In the picture, a plump bird is perching on a clump of reeds by a river, bending the branches. It seems to have just finished its work, and is taking a brief break undisturbed. In *The Book of Songs*, the first collection of Chinese poems, a similar scene is portrayed where the reeds along a river are showered in moist morning mist, with a strong autumn flavor.

Colors

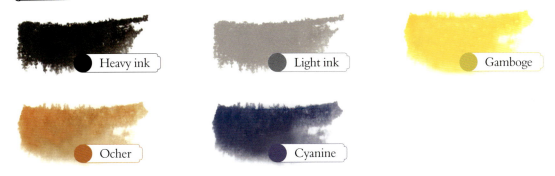

Heavy ink

Light ink

Gamboge

Ocher

Cyanine

Painting Techniques

In this part, we will gain a better understanding and grasp of *cun*-dotting stroke by painting reeds during White Dew. When painting, slightly flatten the hairs of the brush to dot and wipe continuously to sketch the rough shape. Note the contrast between dark and light.

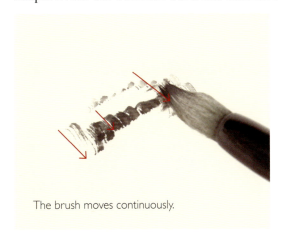

The brush moves continuously.

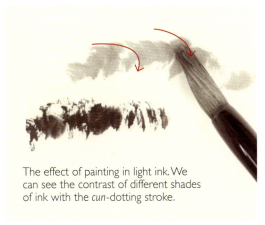

The effect of painting in light ink. We can see the contrast of different shades of ink with the *cun*-dotting stroke.

Steps

1

Paint the reeds with *cun*-dotting strokes. Paint the first group of reed catkins in ocher and light ink blended at 7:3.

2

When the first group of reed catkins is done, increase the proportion of ink to paint the darker reed catkins. Then dip your brush into light ink to enhance the reed catkins around.

CHAPTER FOUR Autumn Painting 87

3

Sketch the reed rod in light ink.

4

Add the twigs between the reed catkins and the rod.

5

Paint a second reed immediately to the upper left of the first rod.

6

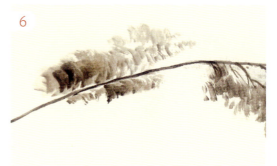

Continue to add the reed catkins.

7

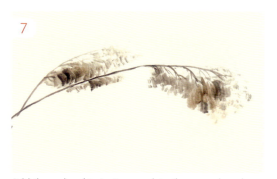

Add the rod and twigs to complete the second reed.

8

Blend ocher, a small amount of gamboge, and light ink to paint a third reed at the bottom of the picture in the same way.

9

Add details to complete the third reed.

10

Blend ocher and ink at 6:4 to paint the leaves.

11

Continue to complete all the leaves.

12

Paint the bird—a relatively simple process. Follow the steps and note the intensity of the ink while painting. Its head should be in light ink and its body, tail, and feet in heavy ink. First sketch its beak in heavy ink.

13

Sketch the eye.

14

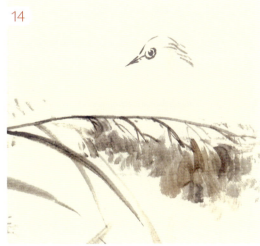

Paint the head in light ink.

15

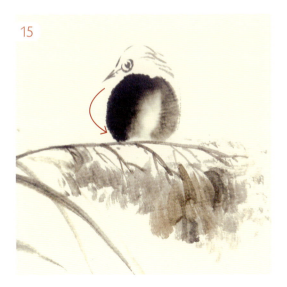

When painting the body, dip the tip of your brush in the ink, and move it from the top downward to paint a small half arc. Dip the tip in the ink and paint the body with two strokes.

CHAPTER FOUR Autumn Painting 89

16

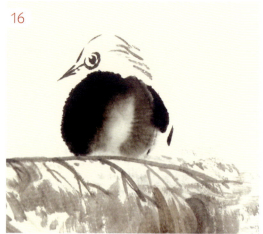

Dip the tip in heavy ink and paint the small wing on the right.

17

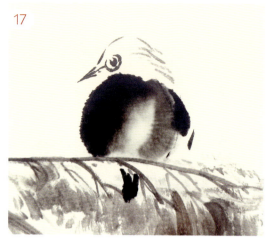

Paint the tail in heavy ink.

18

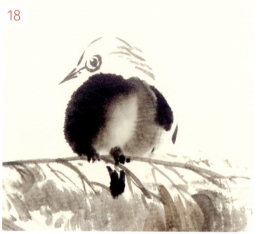

Sketch the feet in heavy ink.

19

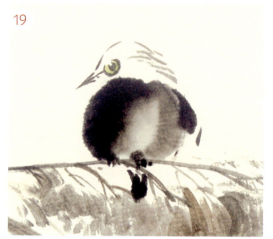

Dot and color the eye in gamboge.

20

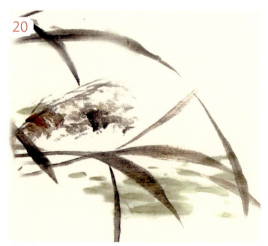

Blend cyanine and gamboge at 3:7 to make green. Use full wipe stroke to enhance the water lines by gently dotting with the tip of your brush.

21

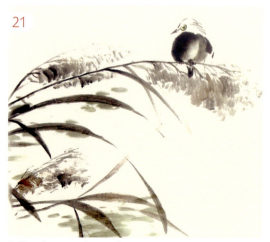

Refine the water lines. The picture is now complete.

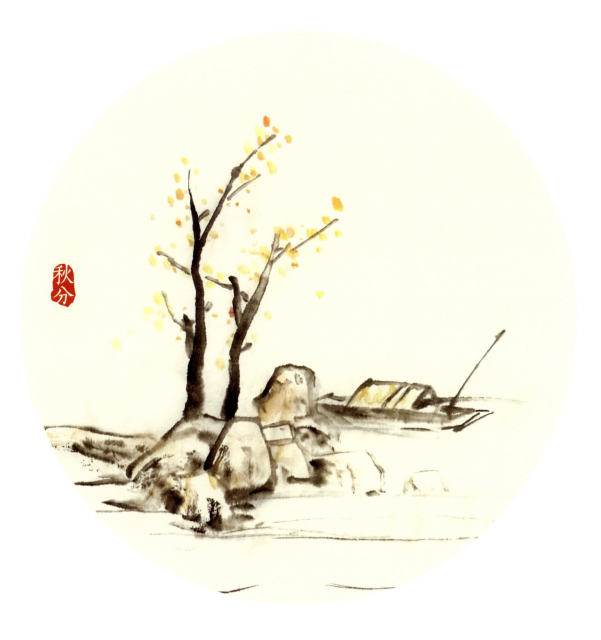

4. Autumn Equinox

Autumn Equinox is the 16th of the 24 solar terms, falling between September 22 and 24, marking the midpoint of autumn when day and night are of the same length. This point of the autumn is typified by cool winds, feasts of ripe crab, blooming chrysanthemum, and the fragrance of osmanthus.

 This is a landscape sketch featuring rocks, two trees, and a fishing boat. The simple scene contains golden leaves falling slowly onto the serene water, rendering a sense of autumn tranquility.

CHAPTER FOUR　Autumn Painting

Colors

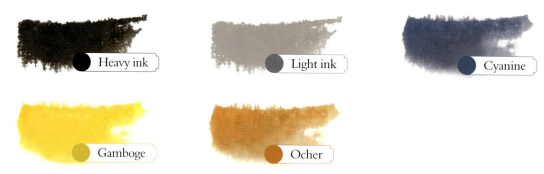

Painting Techniques

When painting rocks with the *xieyi* (freehand) technique, *cun-ca* is another essential method alongside the pressing-lifting and pause strokes. Let's take a closer look at the technique. *Cun* and *ca* are two separate strokes. There are various types of *cun*, particularly in landscape painting, used to present different textures. Here we will simply learn to *cun* the rocks with *cefeng*, and to *ca* with a dry brush.

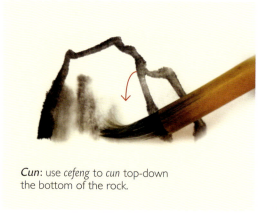

Cun: use *cefeng* to *cun* top-down the bottom of the rock.

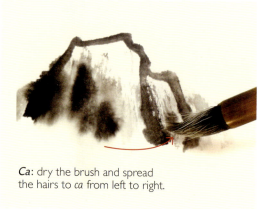

Ca: dry the brush and spread the hairs to *ca* from left to right.

Steps

1

When painting the rock, note that *cun* and *ca* are done after the outline of the rocks is sketched so as to highlight the perspective of the rocks. First, sketch the rock in heavy ink.

2

Add the hidden rocks.

Enhance the outline of the rocks.

Continue to add strokes to the left to enhance the outline of the rocks.

Add the rocks to the right.

Cun and *ca* the rocks with *cefeng*.

Complete *cun-ca* for each part of the rocks.

Paint in heavy ink from the root upwards to sketch a branch.

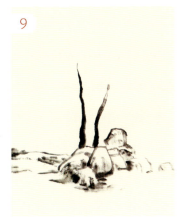
Add a second branch.

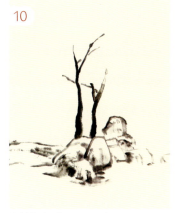
Add forked twigs to the two branches.

CHAPTER FOUR Autumn Painting 93

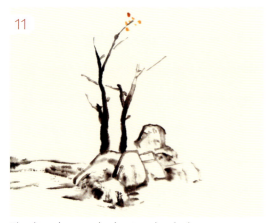

Blend gamboge and ocher to color the leaves to highlight the autumn flavor.

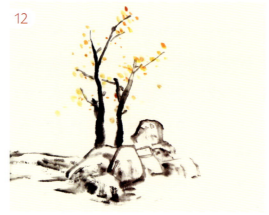

Refine the leaves, and note the variation in size and density.

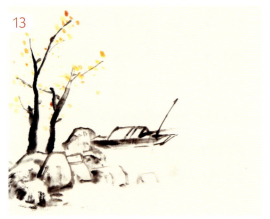

Add a fishing boat behind the rocks.

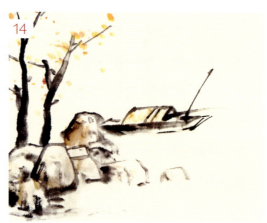

Color the fishing boat in gamboge and cyanine, and the rocks in ocher.

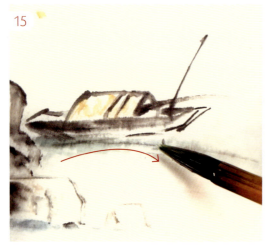

Use the ink breaking color method to represent the waves under the fishing boat. First, paint a stroke with *cefeng* in light cyanine, and when it is dry, gently sketch the junction between the fishing boat and the water surface in heavy ink blended with ocher.

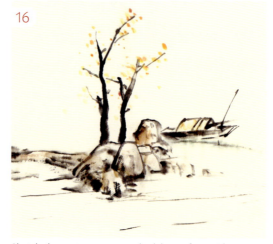

Sketch the water waves on the lake surface with *zhongfeng*. The picture is now complete.

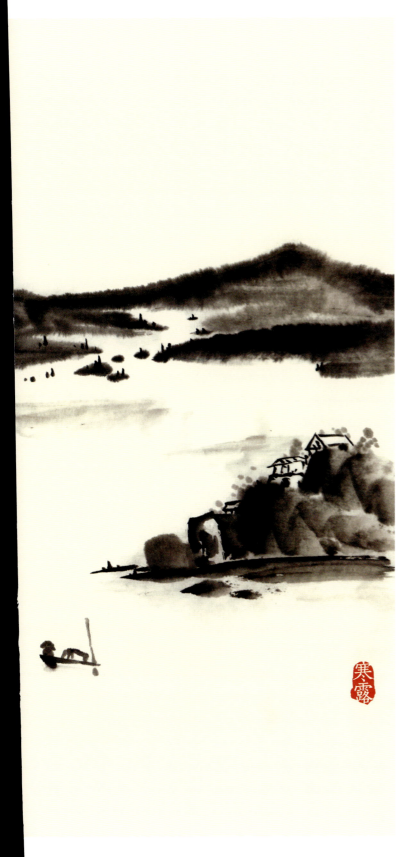

5. Cold Dew

Cold Dew is the fifth solar term of the autumn, falling between October 7 and 9, indicating that the temperature is dropping and the dew increasing. At this time, folk activities include mountain climbing and drinking chrysanthemum tea.

This picture is a landscape painting—one of the three major elements of Chinese painting, the other two being figure painting and bird & flower painting. This landscape painting is not colored, and presents layers of mountains with the variation in ink intensity. The chill of late autumn is depicted with the wet-on-wet painting method, and the water is left blank, creating a boundless world of refreshing tranquility.

CHAPTER FOUR Autumn Painting 95

Colors

 Heavy ink

 Light ink

Painting Techniques

To highlight the sense of chill during Cold Dew, we will learn a new technique called wet-on-wet painting, which gives a sense of dampness. It is slightly similar to the broken ink method, as both express moist strokes, but the former presents a better overall effect.

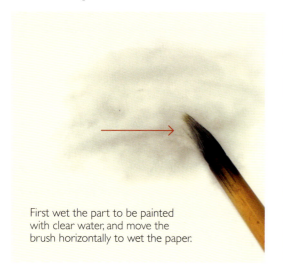

First wet the part to be painted with clear water, and move the brush horizontally to wet the paper.

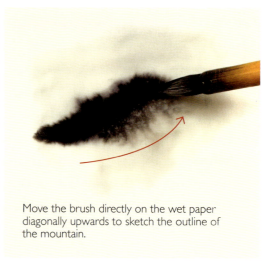

Move the brush directly on the wet paper diagonally upwards to sketch the outline of the mountain.

Steps

1

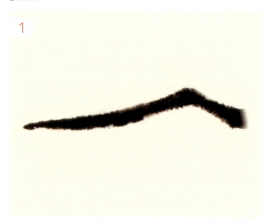

Paint the distant mountains with wet-on-wet painting, in heavy and light ink alternately to enhance the structural layers of the mountain. Wet the paper first, and paint the first stroke in heavy ink with the wet-on-wet technique.

2

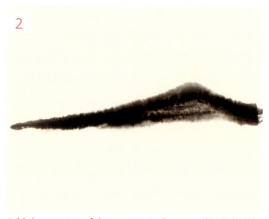

Add the interior of the mountain downward in light ink.

3

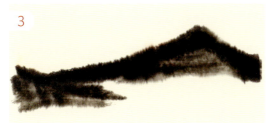

Enhance the layers of the mountain on the left.

4

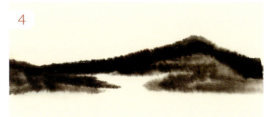

Enhance the layers of the mountain on the right in light ink.

5

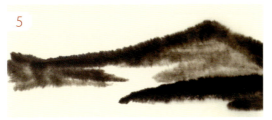

Add heavy ink at the lower right.

7

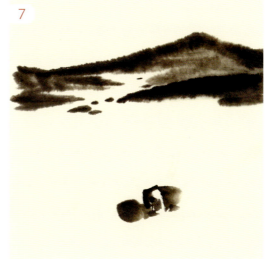

6

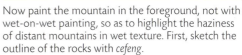

Dot in heavy ink.

Now paint the mountain in the foreground, not with wet-on-wet painting, so as to highlight the haziness of distant mountains in wet texture. First, sketch the outline of the rocks with *cefeng*.

8

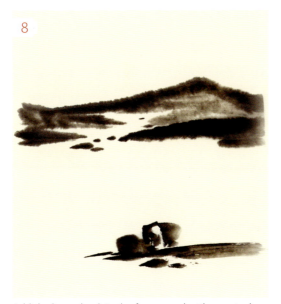

Add the larger bank in the foreground with one stroke.

9

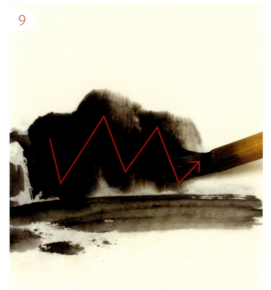

Paint the rock on the bank with the ink splash method, and use *cefeng* to link them in one stroke.

CHAPTER FOUR Autumn Painting 97

10

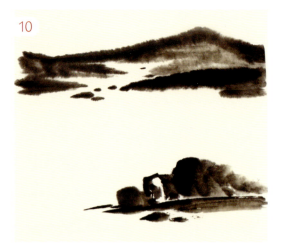

Paint the rock on the right side of the bank with the ink splash method.

11

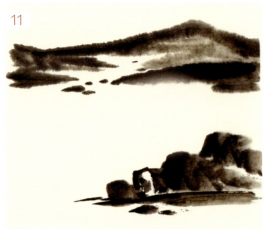

Add a second rock to the right with the ink splash method.

12

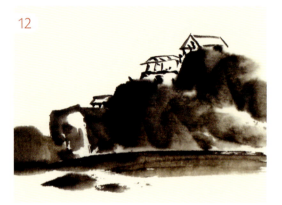

Sketch the houses with fine strokes.

13

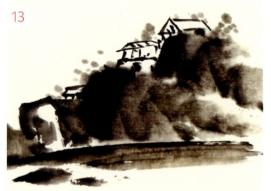

Dot in light ink to represent trees behind the houses.

14

Add a small boat in the foreground, and apply two ink dots on the left of the boat to depict a fisherman with a hat at the stern.

15

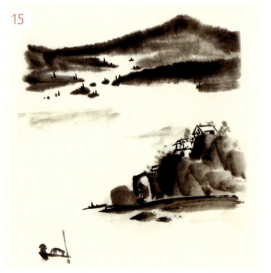

Color the lake surface with *cefeng* in light ink to complete the painting.

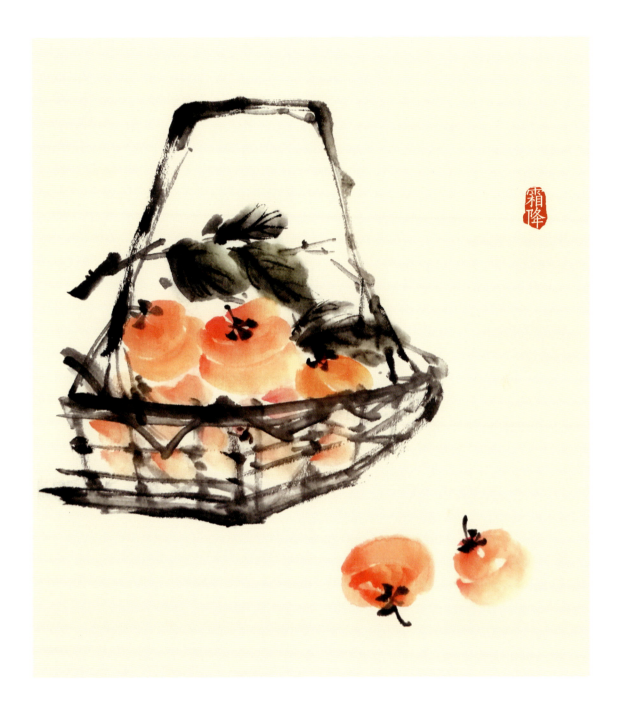

6. Frost's Descent

Frost's Descent is the last solar term in autumn, falling between October 23 and 24, when the temperature drops abruptly and dew condenses into frost. Chinese people enjoy folk activities such as eating persimmons and appreciating chrysanthemums.

Persimmons bear fruit in late autumn, which are bright red, juicy, tender, and pleasantly sweet. The persimmons in this picture have just been picked from the tree. They are ripe and heavy, with two tumbling out of the basket. In China, persimmons have been popular since ancient times because of their festive and attractive appearance, resembling small lanterns from a distance. Endowed with auspiciousness and good luck, they are often hung in front of doors on holidays to create a festive atmosphere.

Colors

Heavy ink · Light yellow · Ocher

Eosin · Gamboge · Cyanine

Painting Techniques

The techniques and skills of Chinese painting emphasize the use of different strokes in specific cases. In the Minor Heat section, we learned how to paint a lychee using turning with *cefeng*. Now, we will gain a better understanding and grasp of turning with *cefeng* and varying the color by painting the persimmon. Unlike the structure of the lychee, which was painted with one stroke on either side, the persimmon is painted by overlapping the upper and lower strokes. When painting, dip the belly of your brush into gamboge and the tip into eosin. Start with *cangfeng* and then turn to *cefeng*.

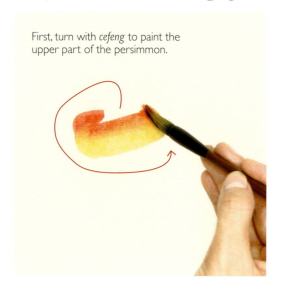

First, turn with *cefeng* to paint the upper part of the persimmon.

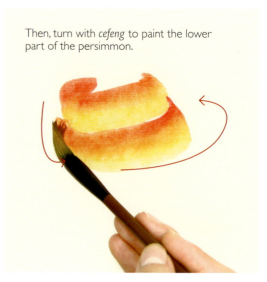

Then, turn with *cefeng* to paint the lower part of the persimmon.

100　Chinese Brush Painting: Four Seasons

Steps

1. Paint the basket with *zhongfeng* in heavy ink for the first stroke.

2. Paint the second stroke in a zigzag.

3. Paint the bottom of the basket.

4. Paint the mesh structure of the basket with *zhongfeng*.

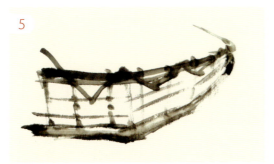

5. Refine the structure with vertical lines.

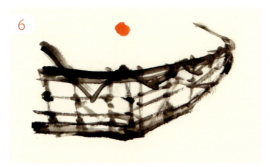

6. Blend light yellow, ocher, and eosin in 6:2:2 to paint the first stroke of the persimmon.

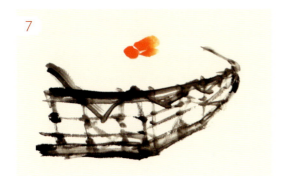

7. Add the second and third strokes of the persimmon.

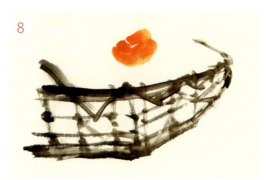

8. Paint the persimmon by turning the brush with *cefeng*.

CHAPTER FOUR Autumn Painting | 101

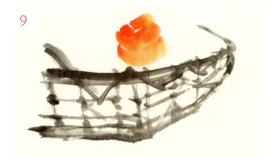

9

In the same way, paint the lower part to complete the first persimmon.

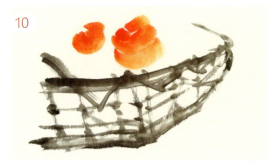

10

Paint a second persimmon to its immediate left.

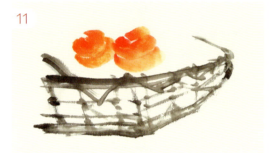

11

Paint the second half to complete the second persimmon.

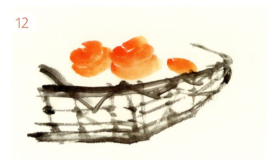

12

Add a third persimmon on the right corner of the basket.

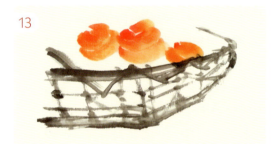

13

Complete the third persimmon.

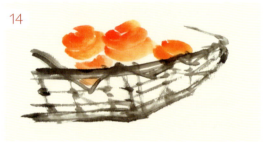

14

Add dots in the gaps in the basket where the persimmon is blocked by the mesh. Note the variation in color when painting the persimmons in the basket, keeping their shape in mind, and making the color near the base darker.

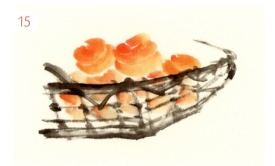

15

Fill the gaps to complete the persimmons blocked by the mesh.

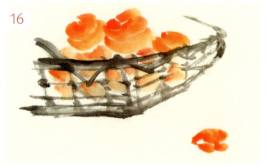

16

Paint the persimmon outside the basket to its lower right, and paint the deeper part near the base first.

102 Chinese Brush Painting: Four Seasons

Turn the brush with *cefeng* to complete a persimmon.

Add a second one in the same way.

Blend cyanine, gamboge, and ink at 5:3:2 to paint the leaves.

Complete the top three leaves.

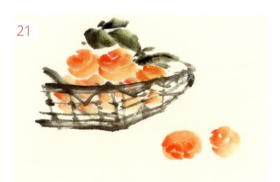

Add the leaf to the right.

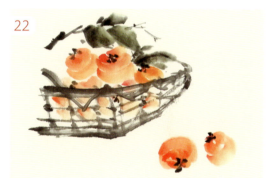

Sketch the stem of the leaves and the fruit base in heavy ink.

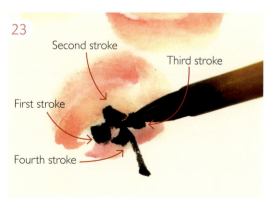

When painting the base, move the brush from the outside in with heavy ink.

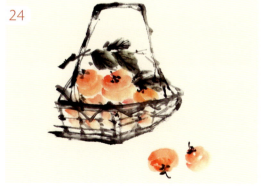

Paint the handle of the basket in heavy ink, and sketch the leaf veins with a fine brush. The picture is now complete.

CHAPTER FOUR Autumn Painting 103

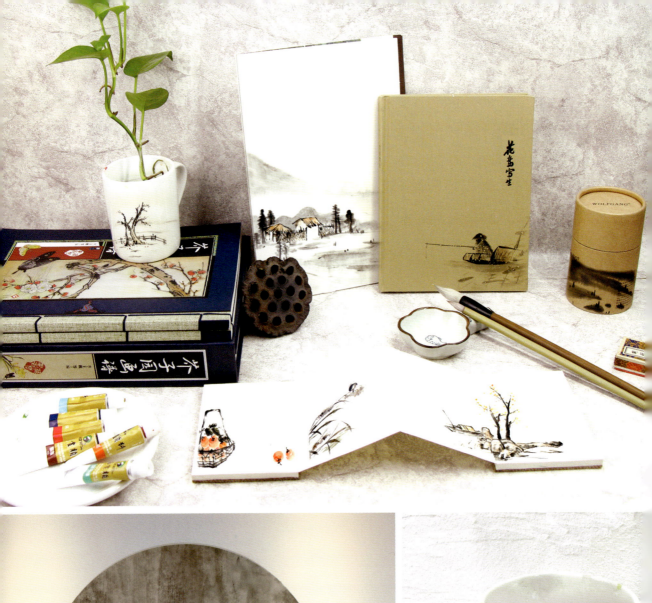
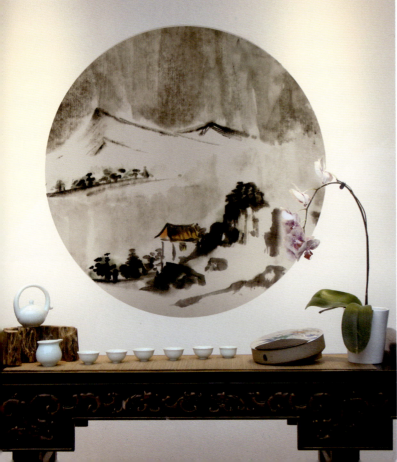

CHAPTER FIVE
Winter Painting

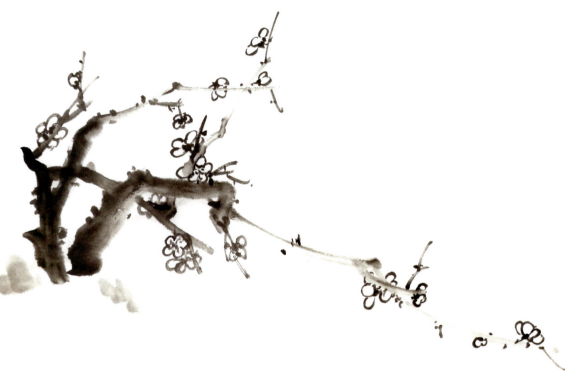

When winter comes, the land is covered with snow, icicles hang from branches, and the sun shines on the frozen river, rendering a pure and solemn beauty.

In this chapter, we will depict the solar terms from Beginning of Winter to Major Cold. When it comes to winter, people often think of dancing snowflakes and a welcoming dinner table indoors, in contrast to the cold outside. In Chinese culture, the flowers that bloom in winter are endowed with a tough and hardy character to survive the severe cold, which will be represented in the pictures in this chapter.

On facing page

Fig. 16 The application of ink painting on stationery, home decor, and various items for daily use.

Fig. 17 Plum blossoms.

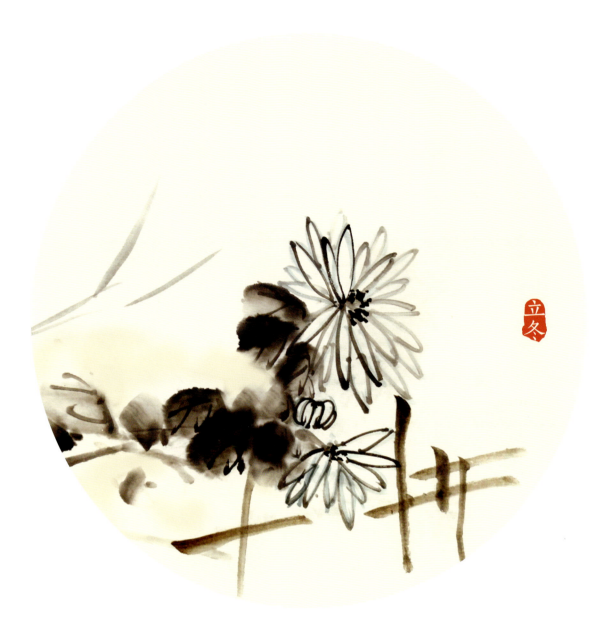

1. Beginning of Winter

Beginning of Winter is the first solar term in winter, falling between November 7 and 8, when all living things are ready for recuperation and rehabilitation. Chinese people have the customs of eating dumplings and safeguarding their health through their diet.

The scene depicted in this picture is similar to an image in the verse "picking chrysanthemums in the garden" by Tao Yuanming (365–427), a poet

of the Eastern Jin dynasty (317–420). Tranquil, leisurely, and solemn, the flowers give a sense of plain and serene beauty. The chrysanthemum—the centerpiece of the picture—is one of the top ten most renowned flowers in China, with a long history of cultivation and a wide variety of strains. As it is not afraid of the cold, it has been endowed with the qualities of tenacity, nobility, and longevity since ancient times, and tens of thousands of literary and artistic works have taken it as their subject.

Colors

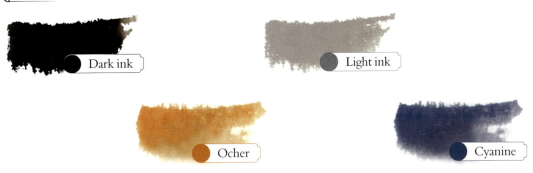

Dark ink

Light ink

Ocher

Cyanine

Painting Techniques

The chrysanthemum is painted in a way similar to the magnolia in spring, using the double-outline method. A tip for rendering the layers of petals in ink: for flowers with more petal layers such as chrysanthemums, we can alter the intensity of ink, with the petals in the front more solid in heavy ink, and the petals at the back more indistinct, in lighter ink.

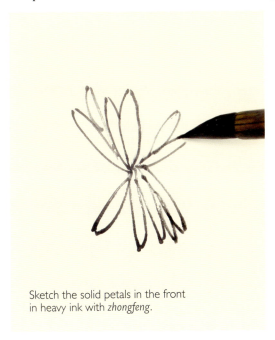

Sketch the solid petals in the front in heavy ink with *zhongfeng*.

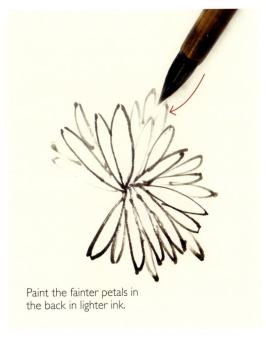

Paint the fainter petals in the back in lighter ink.

CHAPTER FIVE Winter Painting 107

Steps

1 Sketch the outline of the chrysanthemum using the double-outline method. Sketch the first stroke in light ink.

2 Sketch the second stroke using the double-outline method to form a petal.

3 Add the second and third petals.

4 Continue to enhance the petals and note the variation in ink color.

5 Complete the first chrysanthemum.

6 Sketch a chrysanthemum bud below.

7 Paint a second chrysanthemum to the lower right of the bud.

8 Complete all the chrysanthemums.

108 Chinese Brush Painting: Four Seasons

Dip the brush in light ink and the tip in dark ink to paint the leaf with *cefeng*.

Continue to enhance the leaves.

Continue to enhance the leaves in light ink.

Add the leaves on the left side of the picture.

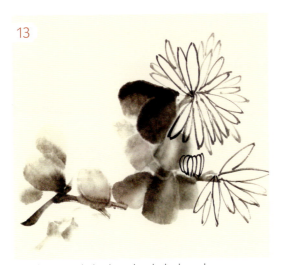

Dip the tip in dark ink to sketch the branch.

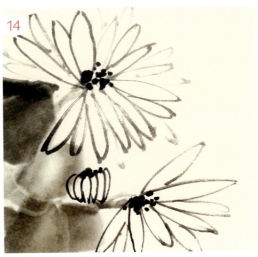

Dot the stamens in dark ink.

CHAPTER FIVE Winter Painting 109

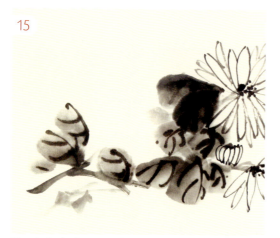

Sketch the leaf veins in dark ink.

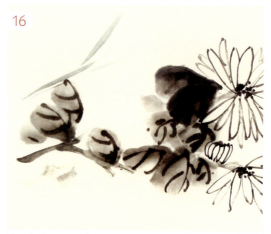

Sketch the grass above the chrysanthemum in light cyanine.

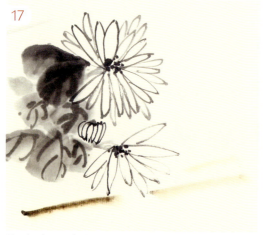

Blend ocher and ink at 7:3 to paint the fence with *zhongfeng*.

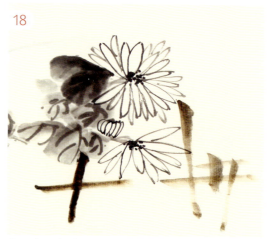

Complete the fence.

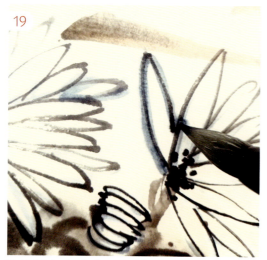

To highlight the feeling of cold in Beginning of Winter, color the petals in light cyanine.

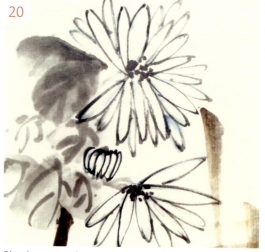

Blend water and cyanine at 8:2 to sketch the outline of all petals. The picture is now complete.

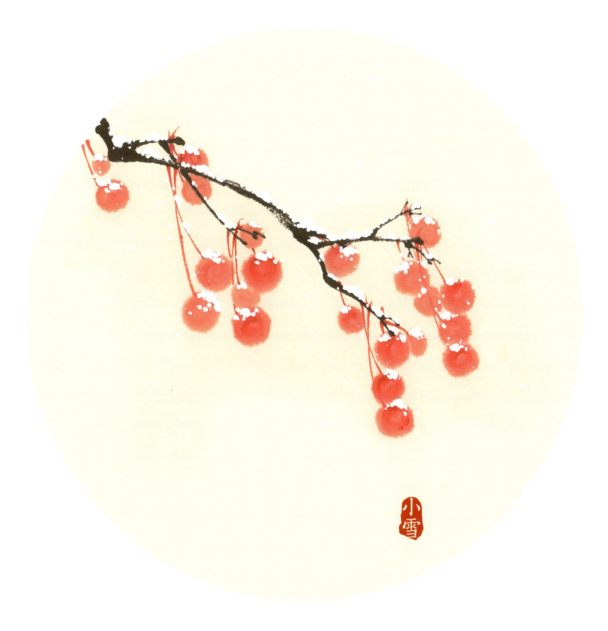

2. Minor Snow

Minor Snow is the 20th of the 24 solar terms, falling between November 22 and 23, when the weather is getting colder and the temperature drops below zero.

 This picture depicts a scene after snowfall, where a branch of red fruits is coated with snow. With the sharp contrast in color, the snow makes the red fruits look even more appetizing.

CHAPTER FIVE　Winter Painting

Colors

Painting Techniques

In this section, we will use trees to highlight the snowy scene, using various techniques to express tree branches in freehand brushwork. It boils down to a rule called "branching in four directions," that is, into the front, the back, the left, and the right. That apart, we must note the size of the forking branches.

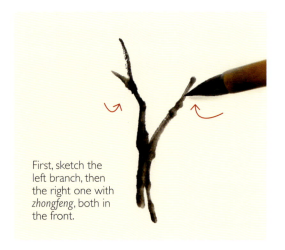

First, sketch the left branch, then the right one with *zhongfeng*, both in the front.

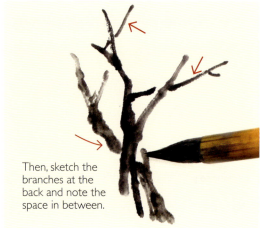

Then, sketch the branches at the back and note the space in between.

Steps

Paint the thicker branch in heavy ink with *zhongfeng*.

Add some thinner branches.

Continue to add more forking branches.

112 Chinese Brush Painting: Four Seasons

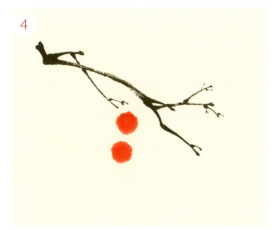

Blend eosin and gamboge to paint two fruits with one stroke making a circle. When painting the fruits, gently point at the paper with the tip to draw a clockwise circle.

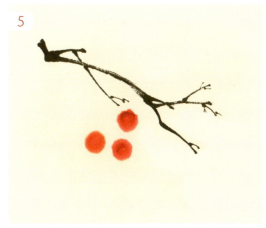

Increase the proportion of gamboge and blend it with eosin to paint another fruit.

Continue to paint more fruits. Note that you are painting the fruits in the front, so you need to leave space.

Dilute the previous red color to paint the smaller fruits at the back.

Continue to paint more fruits at the back, in the same color as in step 7.

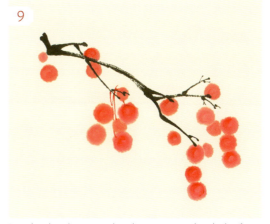

Dip the detail painting brush in eosin to sketch the fruit stalks with *zhongfeng*. When painting, move the brush quickly and smoothly to stay clear of the fruit.

CHAPTER FIVE Winter Painting | 13

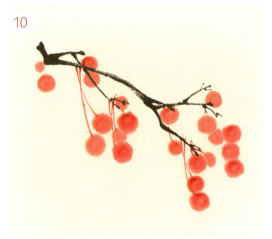

Stay in the same tilting direction when painting other fruit stalks to represent the blowing of a breeze.

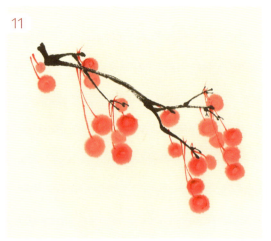

Paint a stalk for each fruit.

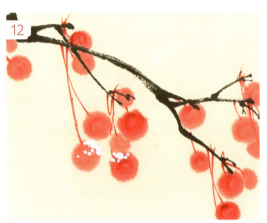

Dip a small brush in titanium white and dot snow on the fruits. Note that the snow will gather on the top of the fruit, so you need to render the difference in size when dotting.

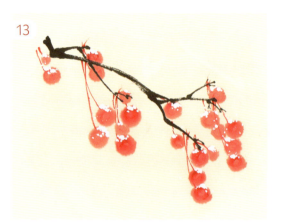

Dot every fruit with snow.

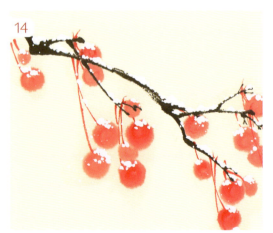

Paint the snow on the branches. Snow gathers in the forks of the branches, so you should paint more snow there.

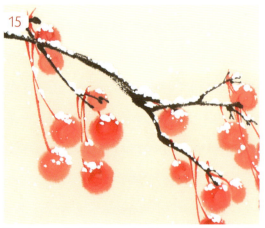

Use the powder-flicking method (see p. 116) to sprinkle snowflakes of different sizes to complete the painting.

Chinese Brush Painting: Four Seasons

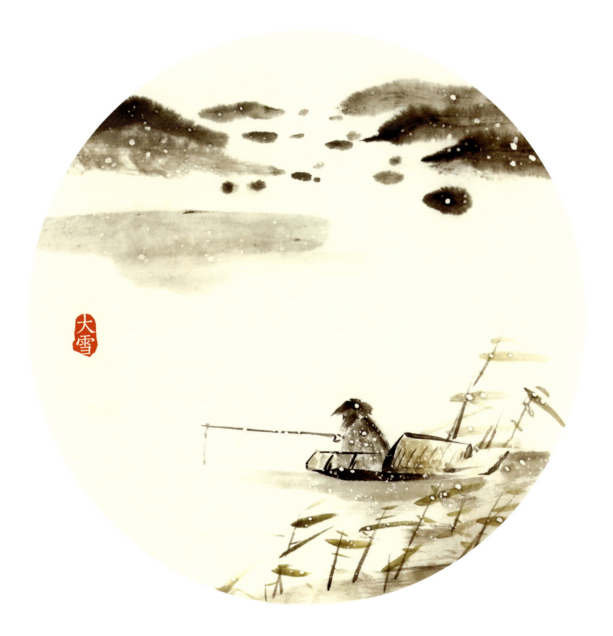

3. Major Snow

Major Snow is the third solar term in winter, falling between December 6 and 8, when the temperature drops significantly and the snowfall increases. Chinese people enjoy activities such as customary snowball fights, scenic snow tours, and meat preservation.

The snow scene in this picture derives from a poem by Liu Zongyuan (773–819), a Chinese poet from the Tang dynasty, which depicts a day of heavy snow when a straw-cloaked old man sits in a boat, fishing on a river

clad in snow against the backdrop of deserted mountains. The picture primarily features the snowy scene, coloring mostly in black and white to render the freezing cold of the mountains.

Colors

Heavy ink

Light ink

Titanium white

Ocher

Painting Techniques

In addition to the widely used techniques employed to depict scenes, Chinese painting has many other special techniques. Here we will learn about one of these—the powder-flicking method—to depict snow. It involves tapping a full brush head on the shaft of another brush, so that the color dots fall naturally onto the picture, forming a natural snowy scene.

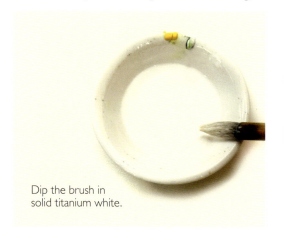

Dip the brush in solid titanium white.

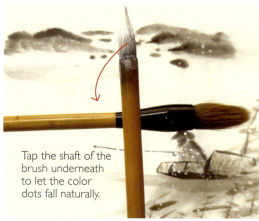

Tap the shaft of the brush underneath to let the color dots fall naturally.

Steps

1

Paint the boat first. Paint the bottom in heavy ink with *zhongfeng*.

2

Sketch the outline of the boat with *zhongfeng*.

3

Add the body and top of the boat.

4

Paint the stern with three short strokes.

5

Paint the X-shaped texture on the canopy in light ink.

6
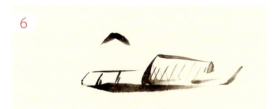
Sketch the outline of the fisherman's bamboo hat in heavy ink.

7
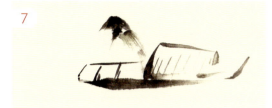
Add a stroke with *zhongfeng* under the bamboo hat to express the fisherman's beard. Then, scatter the hairs to paint the straw rain cape (see step 8 for details).

8
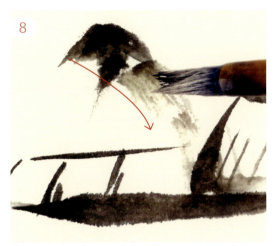
Flatten the brush tip, and then use *cun* and *ca* in drier ink.

9
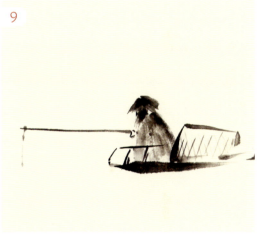
Highlight the fisherman's back in heavy ink, and add a fishing rod. Add a fishing line in light ink.

10
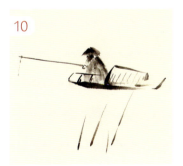
Blend ocher and light ink at 3:7 to paint the reed stems with a fine brush in *zhongfeng*.

11
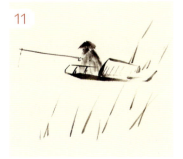
Enhance the reed stems. When sketching the stems of the reeds, be careful not to place them evenly in the picture, but with variation in length and density to make the scene more vivid.

12

Blend ocher and light ink at 5:5 to paint the reed leaves.

CHAPTER FIVE Winter Painting | 117

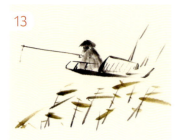

Enhance the leaves.

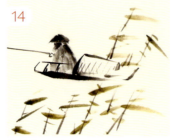

Add distant leaves.

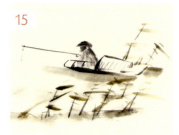

Wipe the interface between the boat and the lake surface with *cefeng* in light ink, and between the reeds and the water surface.

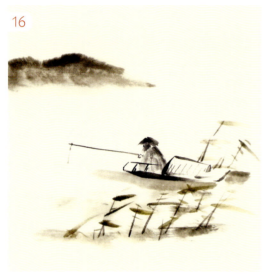

Add distant mountains in heavy ink using the wet-on-wet painting method.

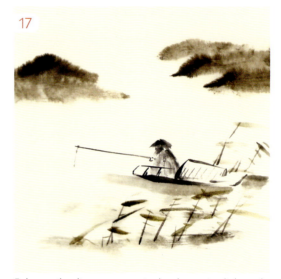

Enhance the distant mountains by alternating light and heavy ink.

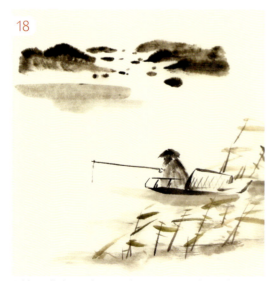

Add small dots in heavy ink to represent the rocks.

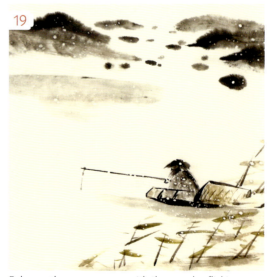

Enhance the snowy scene with the powder-flicking method in thick titanium white.

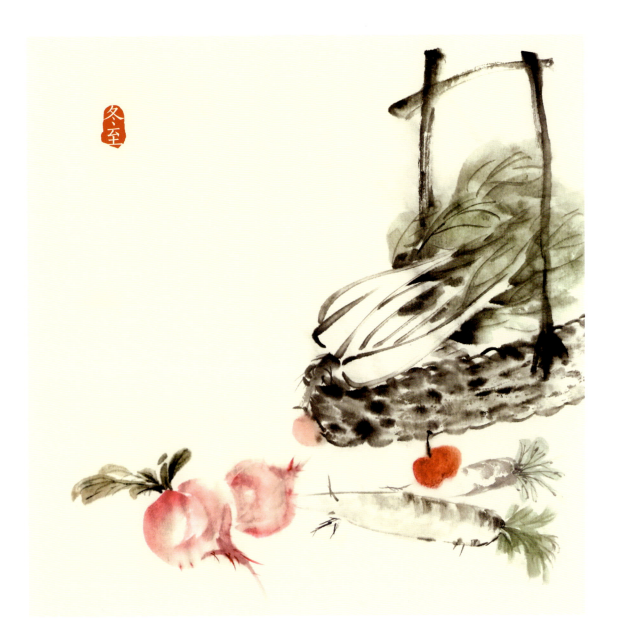

4. Winter Solstice

Winter Solstice, the fourth solar term of the winter, falling between December 21 and 23, is a traditional Chinese festival of ancestor worship as well as being a key solar term. Cuisine at this time includes dumplings, glutinous rice balls, and mutton soup.

 Chinese people value the notion of staying healthy through nutrition, and believe that Winter Solstice is an ideal time of the year to put this into practice. This picture depicts a kitchen corner, where radishes, long turnips, Chinese cabbage, and red fruits are spread out on the ground, waiting to become a table of mouth-watering delicacies.

Colors

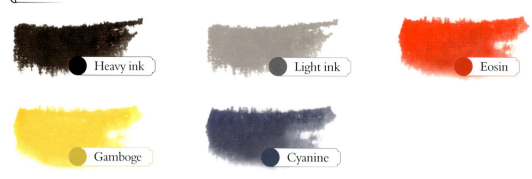

Heavy ink

Light ink

Eosin

Gamboge

Cyanine

Painting Techniques

The techniques of Chinese painting are flexible and changeable. Previously, we learned how to paint with *cefeng*. Here, we will learn the technique of shifting from *cefeng* to full wipe strokes by painting cabbage leaves. We use part of the belly of the brush to start with *cefeng*, and then use the heel to expand the range of strokes and shift to full wipe stroke.

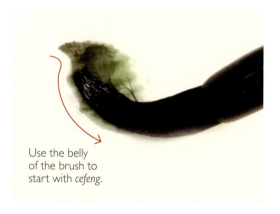

Use the belly of the brush to start with *cefeng*.

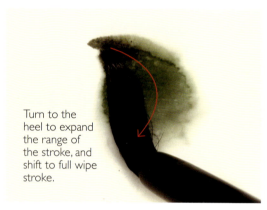

Turn to the heel to expand the range of the stroke, and shift to full wipe stroke.

Steps

1

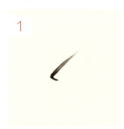

Paint the Chinese cabbage first. For the cabbage stalks, paint with a combination of "pieces" to make the picture clear and orderly. Sketch the first stroke of the cabbage stalk in heavy ink.

2

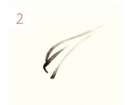

Add a stroke above and below respectively to render a complete cabbage stalk.

3

Add the second Chinese cabbage stalk.

4

Enhance the vegetable stalks blocked in the middle.

120 Chinese Brush Painting: Four Seasons

5	6	7	8
		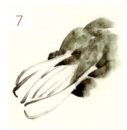	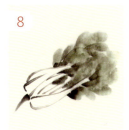
Dip the tip of your brush in a blend of cyanine and gamboge at 5:5 to paint the leaves.	Dip your brush into this blend, and continue to paint the leaves.	Carry on until you have completed all the leaves.	Dip the tip of your brush in ink, and swiftly paint the root of the cabbage.

9	10	11
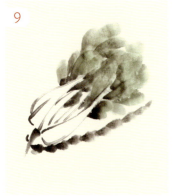	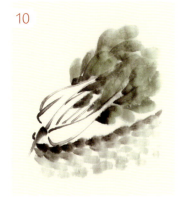	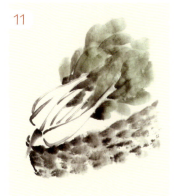
Dot the basket with *cefeng* in heavy ink.	Continue painting with the remaining ink.	Dip the tip of your brush in the ink, and selectively highlight the basket to form dark spots, and highlight the texture of the basket.

12	13	14
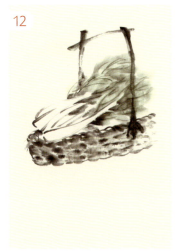		
Paint the basket handle in heavy ink with a dry brush, and sketch the veins on the vegetable leaves.	Sketch the turnip below the basket in light ink. When a variety of vegetables are put in the same picture, combine the items so that they are not all in the same spot. Rather, they should be placed at proper intervals to highlight the main body.	Dip the tip of your brush in heavy ink, and fill the inside of the turnip with *cefeng*.

CHAPTER FIVE Winter Painting

15
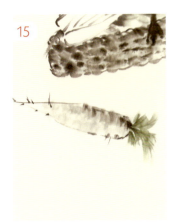
Refine the stigma of the turnip with *zhongfeng*. Blend cyanine and gamboge at 6:4 to paint the turnip leaves. Start with *zhongfeng* and move to *cefeng*. Then, add a small amount of light ink to the turnip leaves, and add the veins with *zhongfeng*.

16
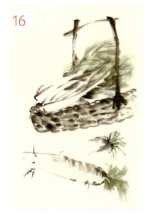
Add a second turnip. Note that the second turnip is partly blocked.

17
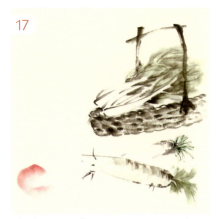
Blend eosin and water at 3:7 to paint the radish.

18
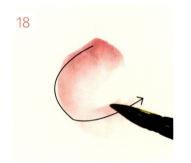
Complete the radish with two broad strokes. Note the variation in color (darker at the tip). Paint in a semicircular direction with *cefeng*.

19

Paint the second stroke to complete the circle.

20

Sketch the tip of the radish.

21

Blend gamboge, cyanine, and eosin at 5:4:1 to paint the leaves. Start with *zhongfeng* and shift to *cefeng*. When painting the leaves, alternate strokes of different sizes to make the leaves look livelier.

22

Sketch the veins in heavy ink. Then add a second radish.

23

Enhance the picture by adding two red fruits, one deep and the other light in color. The darker one sits in front of the basket while the lighter one is hidden behind it. The picture is now complete.

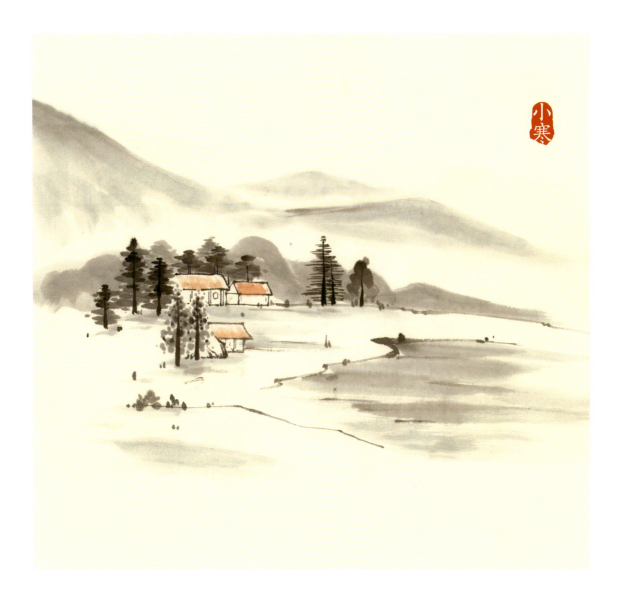

5. Minor Cold

Minor Cold is the fifth solar term of the winter, falling between January 5 and 7, indicating that the coldest days of the year are coming. At this time, customary activities include eating Laba Congee (rice porridge with nuts and dried fruit) and glutinous rice.

 This picture is a small landscape painting where thousands of miles of land are covered with ice and snow. At the foot of the mountain, amidst green pines and cypresses, there are cottages in a natural rural style. As pines and cypresses can endure cold weather and are evergreen, they are often used in Chinese culture to refer to noble and faithful ethics, and carry the auspicious meaning of longevity.

Colors

Heavy ink

Light ink

Cyanine

Ocher

Painting Techniques

Here we will turn to *xieyi* (freehand) landscape to capture the atmosphere of Minor Cold. The mountains and rivers cannot be separated from the trees. Let's take a look at the common ways of rendering distant trees, and learn how to distinguish various types when there are many in the background. The following are the three most commonly used ways of expressing trees in the distance. The first tree is completed by dragging the stroke with the brush belly (*tuofeng*) on the paper; that is, put the brush head on the side on the paper, and drag the brush in the same direction to make smooth and relaxing strokes. The second tree is expressed in the form of dots. The third tree is sketched with *zhongfeng*.

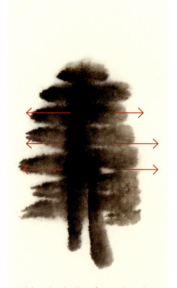

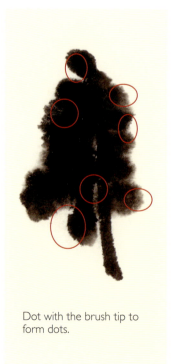

Use the belly of your brush, and hold it horizontally to paint wide lines. Each horizontal track here is composed of left and right strokes.

Dot with the brush tip to form dots.

Sketch the leaves with *zhongfeng* and form thin lines. Each horizontal track here is composed of left and right strokes.

Steps

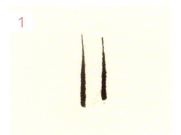

1. Paint the tree trunks in heavy ink. The trees should display their individual differences, with the trunks being of varying heights.

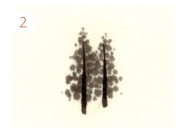

2. Dot the leaves in light ink in the form of small dots.

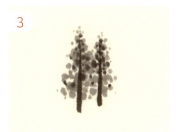

3. Overlay some dots in heavy ink to render the layers.

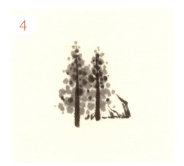

4. Sketch the outline of the rocks behind the trees in heavy ink.

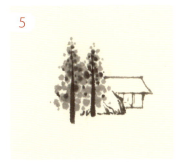

5. Sketch the outline of the house in light ink with *zhongfeng*.

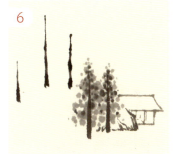

6. Dip your brush in heavy ink to add the trunks behind the house.

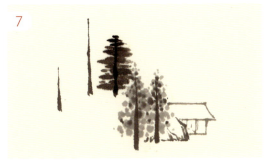

7. Keep the brush hairs horizontal to the paper to paint leaves.

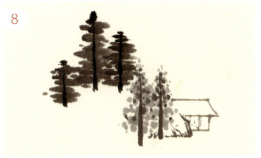

8. Continue to paint the leaves of the other two trees in the same way.

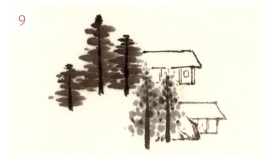

9. Dip your brush in heavy ink to sketch the house at the back, and steer clear of the leaves in the front.

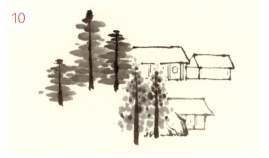

10. Continue to sketch the remaining house.

CHAPTER FIVE Winter Painting 125

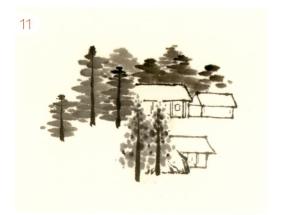

Still keeping the brush hairs horizontal, dip your brush in heavy ink to add the trees at the back of the house, rendering distant trees in light ink to give a sense of perspective.

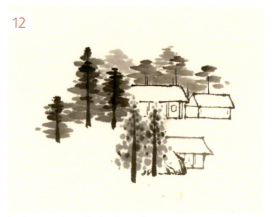

As the woods at the back are far away, you can use a detail painting brush to sketch thinner trunks to give perspective, making the distant objects smaller.

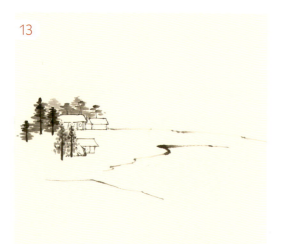

Dip your brush in heavy ink and sketch the ground with *zhongfeng*.

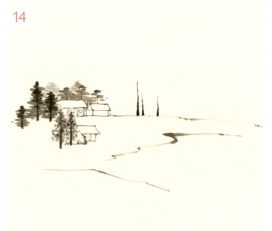

Paint the trunk to the right of the house in heavy ink, and try to render the differences in length.

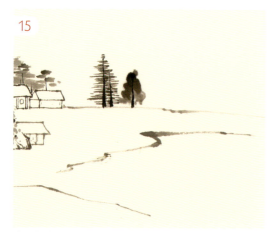

Sketch the leaves on the two trees to the right of the house with *zhongfeng*. Dot the leaves of the tree on the far right in small dots with heavy ink.

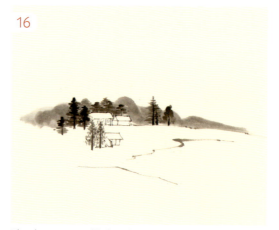

Blend cyanine and light ink at 2:8 to sketch the mountains behind the house.

17

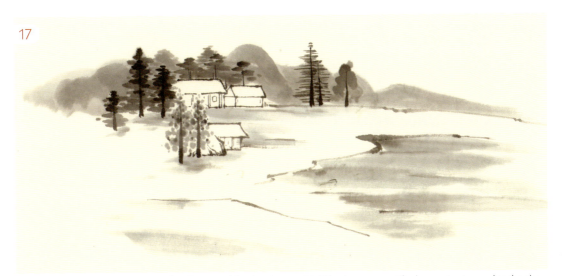

Color the large area of the ground in the same blend as in step 16. Wet the paper with clear water to render the sky. The icy atmosphere of Minor Cold can be expressed through the wet-on-wet painting technique, which we discussed earlier. Painting the distant mountains in this way will give a misty feeling, appropriate to the mood of this solar term.

18

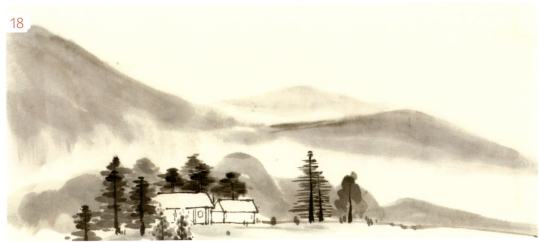

In the "wet" sky, paint the distant mountains in a blend of cyanine and lighter ink at 2:8. Then, dilute the blend to paint the farthest mountain peak.

19

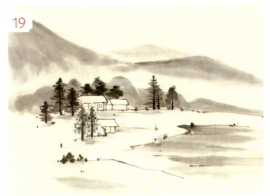

Dot the moss in heavy ink to display the details of the ground to refine the picture.

20

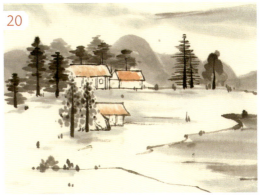

Dip your brush in ocher to paint the roofs. The picture is now complete.

CHAPTER FIVE Winter Painting |27

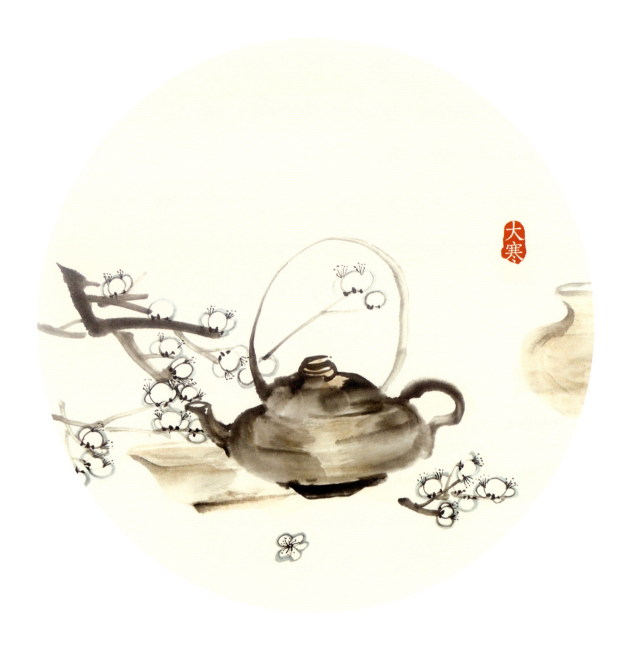

6. Major Cold

Major Cold is the last of the 24 solar terms, falling between January 20 and 21, indicating the extreme of the cold weather. Spring is on its way, ushering in another round of solar terms. Chinese New Year—the most important folk festival in China—also falls in this period, and people are busy welcoming the Lunar New Year with festive joy.

In this picture, lovely plum blossoms are blooming in the cold. Topping the list of China's ten most renowned flowers, it is termed as one of the "four gentlemen flowers," along with the orchid, bamboo, and chrysanthemum. It is also one of the "three companions of winter," together with pine tree and bamboo. Its nobility, resoluteness, and modesty have been valued and applauded by scholars and men of letters down the ages. The act of drinking wine while admiring plum blossoms, as depicted in the picture, is viewed as something of a refined taste.

Colors

Dark ink

Light ink

Ocher

Cyanine

Painting Techniques

Among Chinese painting techniques, *tuofeng* is also termed as dragging the brush, or revealing the hairs' tip. In the Minor Cold picture, we learned how to use *tuofeng* to paint straight lines to present trees. Here, we will use *tuofeng* to paint arcs to represent the different parts of the wine pot, using the stroke in several directions.

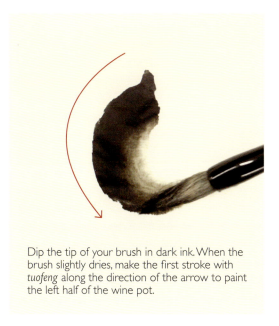

Dip the tip of your brush in dark ink. When the brush slightly dries, make the first stroke with *tuofeng* along the direction of the arrow to paint the left half of the wine pot.

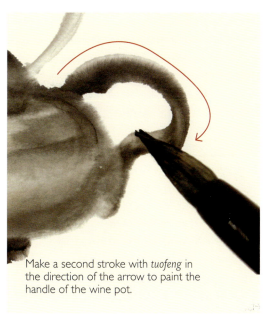

Make a second stroke with *tuofeng* in the direction of the arrow to paint the handle of the wine pot.

CHAPTER FIVE Winter Painting 129

Steps

1. When painting the wine pot, first sketch its outline with broad brushwork, and then refine the details. Now, blend heavy ink and cyanine at 7:3 to paint the top mouth of the pot.

2. Refine the details of the mouth. Then, start with *cefeng* and shift to full wipe stroke to paint the lid of the pot in one stroke.

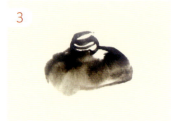

3. Sketch the right half of the lid.

4. Shift *cefeng* to full wipe stroke to paint the belly of the pot.

5. Paint the right half of the pot.

6. Paint the bottom of the pot in heavy ink.

7. Paint the spout of the pot in light ink.

8. Paint the handle of the pot with *tuofeng* in heavy ink.

9. Sketch the loop handle of the pot in light ink.

10. Color the pot in the blend of ocher and water at 2:8.

Chinese Brush Painting: Four Seasons

11

Paint the wine bowl to the left of the pot in the blend of ocher and water at 3:7.

12

Continue to paint the bowl.

13

Paint the bottom of the bowl in the blend of ocher and ink at 7:3.

14

Paint the mouth of the bottle to the right in ocher with *zhongfeng*.

15

Continue to paint the bottle.

16

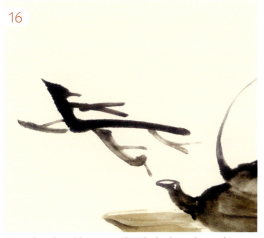

Paint the plum blossoms. Sketch the branches in heavy ink.

CHAPTER FIVE Winter Painting | 131

17

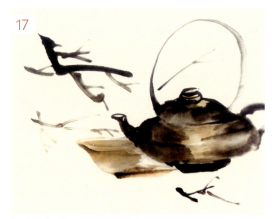

Refine the branches in light ink.

18

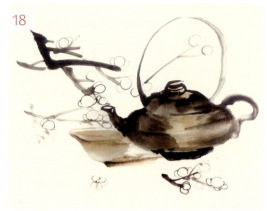

Sketch the petals with *zhongfeng* in light ink and the stamens in dark ink. First, sketch all the plum blossoms with *zhongfeng* using a fine brush, making the buds (a circle) distinct from the flowers (several small circles around a large one).

19

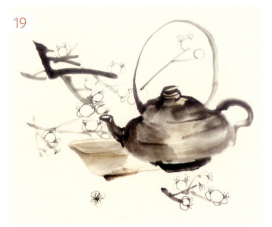

Sketch all the stamens in heavy ink.

20

When painting the base, dot and lift with *zhongfeng* in dark ink. Dot and lift the tip in different directions after dipping in ink.

21

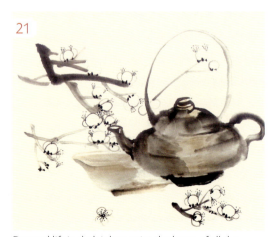

Dot and lift in dark ink to paint the bases of all the flowers and buds.

22

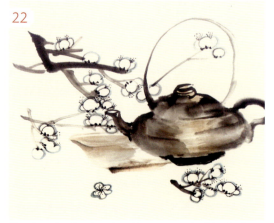

Sketch and color the plum blossoms in the blend of cyanine and water at 2:8 to complete the painting.